CW00519350

Francis Frith's
King's Lynn

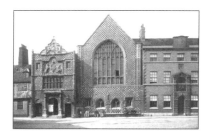

Photographic Memories

Francis Frith's
King's Lynn

Barry Pardue

First published in the United Kingdom in 2001 by
Frith Book Company Ltd

Paperback Edition 2001
ISBN 1-85937-334-8

British Library Cataloguing in Publication Data

Francis Frith's Around King's Lynn
Barry Pardue

Frith Book Company Ltd
Frith's Barn, Teffont,
Salisbury, Wiltshire SP3 5QP
Tel: +44 (0) 1722 716 376
Email: info@francisfrith.co.uk
www.francisfrith.co.uk

Printed and bound in Great Britain

Front cover: **King's Lynn, High Street 1908** 60024

AS WITH ANY HISTORICAL DATABASE THE FRITH ARCHIVE IS CONSTANTLY BEING CORRECTED AND IMPROVED
AND THE PUBLISHERS WOULD WELCOME INFORMATION ON OMISSIONS OR INACCURACIES

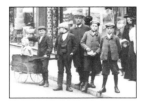

Contents

Francis Frith: *Victorian Pioneer*

FRANCIS FRITH, Victorian founder of the world-famous photographic archive, was a complex and multi-talented man. A devout Quaker and a highly successful Victorian businessman, he was both philosophical by nature and pioneering in outlook.

By 1855 Francis Frith had already established a wholesale grocery business in Liverpool, and sold it for the astonishing sum of £200,000, which is the equivalent today of over £15,000,000. Now a very rich man, he was able to indulge his passion for travel. As a child he had pored over travel books written by early explorers, and his fancy and imagination had been stirred by family holidays to the sublime mountain regions of Wales and Scotland. 'What lands of spirit-stirring and enriching scenes and places!' he had written. He was to return to these scenes of grandeur in later years to 'recapture the thousands of vivid and tender memories', but with a different purpose. Now in his thirties, and captivated by the new science of photography, Frith set out on a series of pioneering journeys to the Nile regions that occupied him from 1856 until 1860.

Intrigue and Adventure

He took with him on his travels a specially-designed wicker carriage that acted as both dark-room and sleeping chamber. These far-flung journeys were packed with intrigue and adventure. In his life story, written when he was sixty-three, Frith tells of being held captive by bandits, and of fighting 'an awful midnight battle to the very point of surrender with a deadly pack of hungry, wild dogs'. Sporting flowing Arab costume, Frith arrived at Akaba by camel sixty years before Lawrence, where he encountered 'desert princes and rival sheikhs, blazing with jewel-hilted swords'.

During these extraordinary adventures he was assiduously exploring the desert regions bordering the Nile and patiently recording the antiquities and peoples with his camera. He was the first photographer to venture beyond the sixth cataract. Africa was still the mysterious 'Dark Continent', and Stanley and Livingstone's historic meeting was a decade into the future. The conditions for picture taking confound belief. He laboured for hours in his wicker dark-room in the sweltering heat of the desert, while the volatile chemicals fizzed dangerously in their trays. Often he was forced to work in remote tombs and caves where conditions were cooler. Back in London he exhibited his photographs and was 'rapturously cheered' by members of the Royal Society. His reputation as a

photographer was made overnight. An eminent modern historian has likened their impact on the population of the time to that on our own generation of the first photographs taken on the surface of the moon.

Venture of a Life-Time

Characteristically, Frith quickly spotted the opportunity to create a new business as a specialist publisher of photographs. He lived in an era of immense and sometimes violent change. For the poor in the early part of Victoria's reign work was a drudge and the hours long, and people had precious little free time to enjoy themselves. Most had no transport other than a cart or gig at their disposal, and had not travelled far beyond the boundaries of their own town or village. However,

by the 1870s, the railways had threaded their way across the country, and Bank Holidays and half-day Saturdays had been made obligatory by Act of Parliament. All of a sudden the ordinary working man and his family were able to enjoy days out and see a little more of the world.

With characteristic business acumen, Francis Frith foresaw that these new tourists would enjoy having souvenirs to commemorate their days out. In 1860 he married Mary Ann Rosling and set out with the intention of photographing every city, town and village in Britain. For the next thirty years he travelled the country by train and by pony and trap, producing fine photographs of seaside resorts and beauty spots that were keenly bought by millions of Victorians. These prints were painstakingly pasted into family albums and pored over during the dark nights of winter, rekindling precious memories of summer excursions.

The Rise of Frith & Co

Frith's studio was soon supplying retail shops all over the country. To meet the demand he gathered about him a small team of photographers, and published the work of independent artist-photographers of the calibre of Roger Fenton and Francis Bedford. In order to gain some understanding of the scale of Frith's business one only has to look at the catalogue issued by Frith & Co in 1886: it runs to some 670 pages, listing not only many thousands of views of the British Isles but also many photographs of most European countries, and China, Japan, the USA and Canada — note the sample page shown on page 9 from the hand-written *Frith & Co* ledgers detailing pictures taken. By 1890 Frith had created the greatest specialist photographic publishing company in the

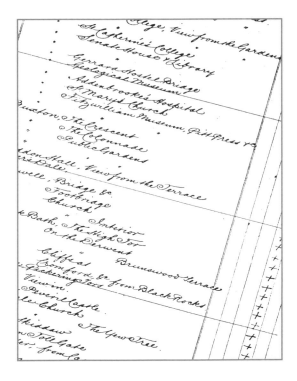

world, with over 2,000 outlets – more than the combined number that Boots and W H Smith have today! The picture on the right shows the *Frith & Co* display board at Ingleton in the Yorkshire Dales (left of window). Beautifully constructed with a mahogany frame and gilt inserts, it could display up to a dozen local scenes.

Postcard Bonanza

The ever-popular holiday postcard we know today took many years to develop. In 1870 the Post Office issued the first plain cards, with a pre-printed stamp on one face. In 1894 they allowed other publishers' cards to be sent through the mail with an attached adhesive halfpenny stamp. Demand grew rapidly, and in 1895 a new size of postcard was permitted called the court card, but there was little room for illustration. In 1899, a year after

Frith's death, a new card measuring 5.5 x 3.5 inches became the standard format, but it was not until 1902 that the divided back came into being, with address and message on one face and a full-size illustration on the other. *Frith & Co* were in the vanguard of postcard development, and Frith's sons Eustace and Cyril continued their father's monumental task, expanding the number of views offered to the public and recording more and more places in Britain, as the coasts and countryside were opened up to mass travel.

Francis Frith died in 1898 at his villa in Cannes, his great project still growing. The archive he created continued in business for another seventy years. By 1970 it contained over a third of a million pictures of 7,000 cities, towns and villages. The massive photographic record Frith has left to us stands as a living monument to a special and very remarkable man.

Frith's Archive: *A Unique Legacy*

FRANCIS FRITH'S legacy to us today is of immense significance and value, for the magnificent archive of evocative photographs he created provides a unique record of change in 7,000 cities, towns and villages throughout Britain over a century and more. Frith and his fellow studio photographers revisited locations many times down the years to update their views, compiling for us an enthralling and colourful pageant of British life and character.

We tend to think of Frith's sepia views of Britain as nostalgic, for most of us use them to conjure up memories of places in our own lives with which we have family associations. It often makes us forget that to Francis Frith they were records of daily life as it was actually being lived in the cities, towns and villages of his day. The Victorian age was one of great and often bewildering change for ordinary people, and though the pictures evoke an impression of slower times, life was as busy and hectic as it is today.

We are fortunate that Frith was a photographer of the people, dedicated to recording the minutiae of everyday life. For it is this sheer wealth of visual data, the painstaking chronicle of changes in dress, transport, street layouts, buildings, housing, engineering and landscape that captivates us so much today. His remarkable images offer us a powerful link with the past and with the lives of our ancestors.

Today's Technology

Computers have now made it possible for Frith's many thousands of images to be accessed almost instantly. In the Frith archive today, each photograph is carefully 'digitised' then stored on a CD Rom. Frith archivists can locate a single photograph amongst thousands within seconds. Views can be catalogued and sorted under a variety of categories of place and content to the immediate benefit of researchers.

Inexpensive reference prints can be created for them at the touch of a mouse button, and a wide range of books and other printed materials assembled and published for a wider, more general readership - in the next twelve months over a hundred Frith local history titles will be published! The day-to-day workings of the archive are very different from how they were in Francis Frith's time: imagine the herculean task of sorting through eleven tons of glass negatives as Frith had to do to locate a particular sequence of pictures! Yet

See Frith at www.francisfrith.co.uk

the archive still prides itself on maintaining the same high standards of excellence laid down by Francis Frith, including the painstaking cataloguing and indexing of every view.

It is curious to reflect on how the internet now allows researchers in America and elsewhere greater instant access to the archive than Frith himself ever enjoyed. Many thousands of individual views can be called up on screen within seconds on one of the Frith internet sites, enabling people living continents away to revisit the streets of their ancestral home town, or view places in Britain where they have enjoyed holidays. Many overseas researchers welcome the chance to view special theme selections, such as transport, sports, costume and ancient monuments.

We are certain that Francis Frith would have heartily approved of these modern developments in imaging techniques, for he himself was always working at the very limits of Victorian photographic technology.

The Value of the Archive Today

Because of the benefits brought by the computer, Frith's images are increasingly studied by social historians, by researchers into genealogy and ancestory, by architects, town planners, and by teachers and schoolchildren involved in local history projects.

In addition, the archive offers every one of us an opportunity to examine the places where we and our families have lived and worked down the years. Highly successful in Frith's own era, the archive is now, a century and more on, entering a new phase of popularity.

The Past in Tune with the Future

Historians consider the Francis Frith Collection to be of prime national importance. It is the only archive of its kind remaining in private ownership and has been valued at a million pounds. However, this figure is now rapidly increasing as digital technology enables more and more people around the world to enjoy its benefits.

Francis Frith's archive is now housed in an historic timber barn in the beautiful village of Teffont in Wiltshire. Its founder would not recognize the archive office as it is today. In place of the many thousands of dusty boxes containing glass plate negatives and an all-pervading odour of photographic chemicals, there are now ranks of computer screens. He would be amazed to watch his images travelling round the world at unimaginable speeds through network and internet lines.

The archive's future is both bright and exciting. Francis Frith, with his unshakeable belief in making photographs available to the greatest number of people, would undoubtedly approve of what is being done today with his lifetime's work. His photographs, depicting our shared past, are now bringing pleasure and enlightenment to millions around the world a century and more after his death.

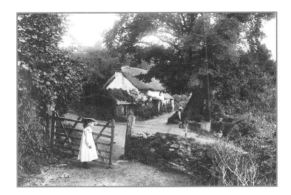

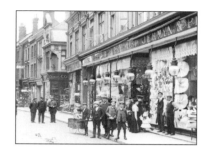

King's Lynn - *An Introduction*

Taken from the Sea

Centuries ago the Wash was much larger than it is today. Located on its south-east corner, King's Lynn was built on the edge of the sea, probably with help from the Romans, and later from the Dutch, who were experts in cutting dykes. From ancient times it was always a populous and flourishing seaport, borough and market town. The country on the eastern side of the town rises in gentle slopes, and presents a distinct contrast to the flat land on the opposite side of the river, where the parishes of West and North Lynn are located. The photographs will show this area before we enter the town proper.

All the navigable rivers in the area met at King's Lynn harbour. One of the early industries here was salt production. Even before the time of the Domesday Book, there is evidence of salt working in nearby Gaywood, Wootton, Rising and Babingley. During the Saxon era there were fifty salt pans operating. In the 11th century, salt was as valuable as money and was used to barter and to pay debts. Trade in other commodities developed, including furs, cloth, farm produce, fish, wine and wood, bringing in merchants and buyers from home and abroad.

Information on the town before the Norman Conquest is hard to find, but we do know that it was some while before King's Lynn became a borough. The bishops as Lords of the Manor had tremendous power. They also owned vast areas of land which included the foreshore, from where the town subsequently developed.

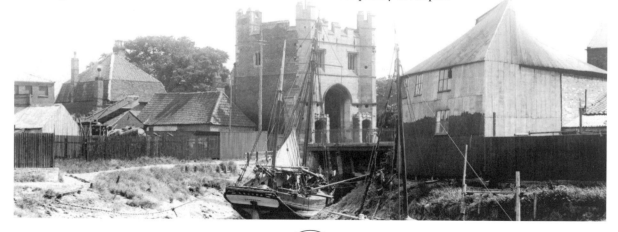

Money Starts to Talk

In the 12th century Herbert de Lozinga, the first Bishop of Norwich, founded St Margaret's ,which is still recognised today as the town's principal church. The bishop authorised the Benedictine monastery at Norwich to run the church, and several monks were accommodated in a small priory attached to the south of the church. When William Turbus, the third Bishop of Norwich, took over, he extended the boundaries to the northern part of the town, where the harbour of Purfleet was located. This became known as the New Land. The chapel of St Nicholas was built here, and so was a huge market. Creating this area, and protecting it by high banks with brick and stone walls, shows forward thinking: this was economically the area which had the greatest potential. Not surprisingly, the monks were not given control; the bishops retained this for themselves. Basically, this was the start of the borough and of the parish of St Margaret.

In 1205, King John came to Norfolk to chastise the barons who had revolted. He stayed at Lynn with his army. On the petition of John Grey, Bishop of Norwich, who later had a palace erected at nearby Gaywood, King John gave the town its first and possibly greatest charter, granting it the power of courts, guilds, tolls, and various charges. Mayors were also appointed. King John visited the town again later in the same year; after staying at a house which later became the Mitre Inn, he presented a beautiful and valuable gift to the Corporation, a silver cup and cover which became known as King John's Cup. Crossing the Wash, he carelessly dropped his baggage into the sea; he continued his journey to Newark Castle, where he died. It is said that his successor Edward went one better when he crossed the Wash - he lost his money as well as his baggage.

The town's first market was a Saturday market at St Margaret's church. The second market was the larger Tuesday market, which covered an area of over three acres. This is where everything of significance took place, from fairs to trials and punishment. In the 13th century the buildings were constructed of wood on stone or brick foundations. Merchants built their houses nearby in an orderly pattern of development, close to the harbours and the market. The Great Fire in 1331 demolished most of these houses: it was all hands to the pumps, with even the chambermaids being paid an extra 2s for bringing in buckets of water to quell the flames. After this devastation, the richer population rebuilt their houses using more brick and stone, including Norfolk flint. However, the poorer people could only use thatch, timber, wattle and daub. In Lynn, 'biggest was best'; the largest buildings were owned by the Church, serving to demonstrate its power and influence.

Land continued to be reclaimed during the

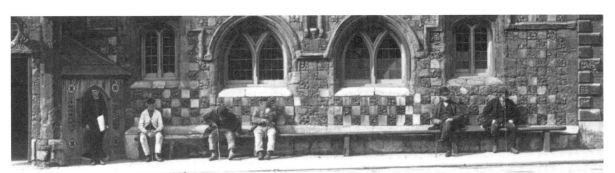

14th and 15th centuries. This was helped by natural forces as well as by human labour, because for over a decade the town suffered from vast amounts of muck and rubbish in the streets, which was generated by the population and by the various industries which accompany a busy market town and port. Hundreds of farm animals were driven to the market; this created additional problems, when their muck and entrails were dumped near or into the fleets, so that the tides or barges could carry it away. In particular the Purfleet was the 'great drain' of Lynn, virtually an open sewer and especially smelly at low tide. The Black Death first came in 1349, causing great loss of life. Eventually it was the fear of the plague that prompted corrective action; even so the disease struck the town no less than six times over the next eight years.

Civil Unrest and the Siege of Lynn

In 1411 the lower classes had become extremely unhappy. They were forced to watch disputes between the bishops, the mayors and the burgesses, who were squabbling over large sums of money obtained from unjust taxation on the lower and the non-ruling classes. The Corporation did its best to clean and smarten up the town, banning the slaughter of animals in the street and ensuring that refuse was collected every day. Wagon and carts

were not allowed to be left in the streets, which had been repaired by a new employee, John Bowers, a paviour. Groups of young people from workhouses were made to pull out weeds and grasses, especially in the market-place. This enthusiasm did not last many years, and soon the fleets were full of rubbish again. Diseases spread, and one family who had only lived in the town for twelve months lost two children. In fact, two people in every one hundred perished, which was worse than in any other Norfolk town: nearly two thousand people a year received medication.

By the 15th century, fairer trading was enforced by regulations, with proper pricing, fixed wages, reasonable opening hours and no Sunday trading. These rules did not apply to innkeepers or cooks; this was probably because the officials enjoyed their food and drink. Everyone else suffered penalties or fines, or even imprisonment, if the rules were broken.

In the Civil Wars the leading lights of the town supported the Royalist cause. Although Norfolk suffered much less than other counties, it still had its share of bloody battles. The town's defences were put to the test against seventeen thousand soldiers, and it was under siege for almost three weeks; when the town surrendered, a fine of £3,200 was levied to alleviate the suffering of the townsfolk. It is not certain whether it was a Dutch ship lying in the harbour, or the army in West Lynn, who took pot

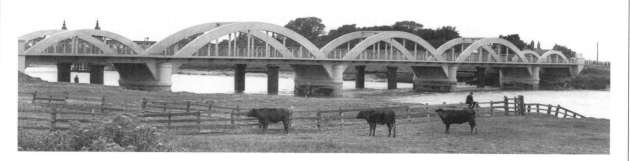

shots at St Margaret's Church during the siege; whoever the culprits were, they damaged the spire and shot off various crosses. A 16lb shot went through a west window and damaged a pillar. Glass showered over the congregation, who lost their hats, hoods and books during the evacuation. No one was hurt, and it cost £5 10s 4d to replace the glass. The cannonball can now be seen suspended from the roof at the entrance to Hampton Court in Nelson Street.

The Name's the Game

The town was seized by Henry VIII in 1539 following the Dissolution of the Monasteries. He honoured it with a 29th charter, which changed its name to King's Lynn. The King's policies led to high-ranking families breaking away from the bishops and acquiring the monastery lands, which increased their status. More merchants and traders came into Lynn: over the next hundred years there were over a hundred and thirty merchants in the town. Their sons received the best education money could buy, which led them to become lawyers, customs collectors and the like. They also purchased country estates in their aspirations to become country gentlemen; some families grew to become the richest townsmen in England, and were to continue as such for many generations. The Turners, the Bagges, and the Bells were enormous influences in Lynn, and their houses and mansions were centres for the entertainment of the town's elite. This was always a good spectacle and entertainment for the poor, who loved to stand and stare.

New taxes were levied on ale houses and inn-keepers, and thirty-six of them were imprisoned for non-payment. In 1587, widow Parker was tied to a cart tail and dragged through the town for incontinence, and later Amy Pointer was ducked as a scold; but these were rare events. From the 1600s the town was to change. Cromwell was invited to visit in 1653, and the Mayor obtained an extra £5 to pay for entertainment for the Protector.

Whoever thought lotteries were a new idea? In the 16th century, the Government issued forty thousand lottery tickets at 10s each to raise money for harbour repairs. In 1569 John Goodwin, four times mayor of Lynn, actually won the first prize of £20,000; there is no record of what he did with it. By now there was a huge manufacturing industry in woollens, weaving, tanning, shoemaking, baking, milling, shipbuilding, ropemaking, and goldsmithing. Some merchants even sailed their own ships.

The Walpole family history goes back to before the Norman Conquest, and for hundreds of years Walpoles have represented the town in municipal government and in Parliament. However, Sir Robert Walpole, probably the most important

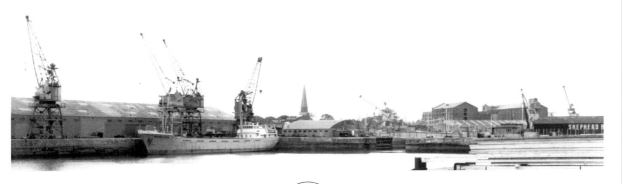

family member, experienced a hitch in his career when he was sent to the Tower for keeping £1,000 from Scottish forage contracts. He lost his seat, but such was his popularity that he was considered a hero and soon elected once more.

Water, water everywhere, nor any drop to drink. As there was no fresh water spring in Lynn, in 1699 the mayors and the town burgesses paid for a ship to be sent to Norway for pump wood to make water pipes. A copious supply of fresh water was ultimately obtained by cutting a canal to the Gaywood river, which had three springs for its source. When the wooden pipes deteriorated, they were taken up, and cast iron pipes were laid at a cost of £1,000. Water rates were 6s for small houses, and a maximum of £6 for the largest. These were based on their rent charges, regardless of the number of rooms, and were quite unfair. The water rent collector, William Hunter, suffered much abuse from shopkeepers for this and other inequalities.

Daniel Defoe, the author of 'Robinson Crusoe', was a regular visitor to Lynn. The surname Crusoe is common in the town. However, the first recorded Robinson Crusoe was born in 1729 and died in 1797. Local historians think that his Christian name was taken from Defoe's book, which was published in 1719. The British Museum has papers suggesting that Lord Oxford wrote the story in prison, and gave Defoe permission to publish it.

When England was at war with America, Lynn supplied many sailors for active service. Most were chased, beaten or knocked out by press-gangs, then handcuffed and dragged aboard ships to catch the next tide - these press-gangs operated during the wars with France and Ireland as well. A stagecoach named the Lord Nelson arrived on 10 October 1801 to announce that the French War had ended. Total illumination from lights in every window was ordered, and the church bells rang all day.

During this period, a quiet man riding his large mare Penny at a smooth gait would arrive at the homes of the elite families, including the Walpoles, the Cokers and the Townsends, all of whom held county seats. He was Dr Burney, the organist of St Margaret's Church, who was supplementing his income of £100 a year as a tutor. He was later to become famous for his 'History of Music'. His daughter Fanny was his opposite in personality, indeed almost brash, but she had an outstanding voice. She became well-known as a novelist (she was the author of 'Evalina'), and her diaries and letters give an interesting picture of life at court - she was keeper of the robes to Queen Charlotte.

In 1825 John Malam established the gas works

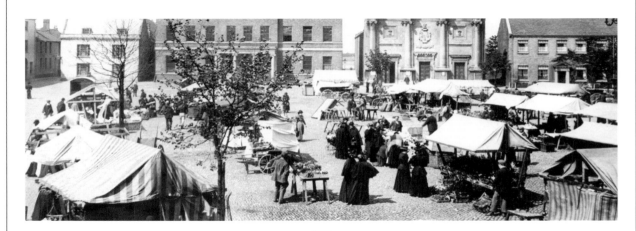

near Southgates. The cost was £14,000, which included the expense of laying seven miles of piping through the town into two gas holders, each of which held 16,000 cubic feet of gas.

The Iron Road Arrives

The ideal conditions that the merchants of Lynn had been experiencing started to come adrift with the influx of the railways and free trade. The merchants' natural reliance on trade by sea, which had lasted over hundreds of years, was virtually wiped out with the extension of the 'iron road', as it was known at that time. Local businessmen rushed to seize the opportunity to tender for building the station houses and the railway tracks. Furious rows took place about where the King's Lynn station should be built. Richard Bagge owned a large field in a convenient spot, so he was given permission to build a temporary wooden station; it was erected by John Sugar in five weeks for £1,770 in August 1846. In 1846 the East Anglian Company opened their railway, using routes close to those of stagecoaches. Eventually an important direct rail link to Ely was constructed, which could then join the great trunk route to London. A more substantial station building was begun in March 1871. As if by magic, the poor stagecoach drivers with their weather-beaten passengers disappeared. Tom Cross, who had a regular coach run from Lynn to Cambridge, unsuccessfully petitioned Parliament through Lord Jocelyn for help to prevent him becoming destitute.

In 1856 Mr George Burnow visited Lynn on a walking tour. He saw a driver beating a horse which had fallen down. 'Give him a pint of ale', said George, 'and I will pay for it'. The horse was given two pints, whereupon he got up. A quarter of an hour later he was seen happily pulling his carriage with the other horses.

Sail Gives Way to Steam

Ships and boats were spending more time in port than at sea because their precious cargoes were now on railway trucks, being sent more quickly (and arriving fresher) to every quarter of the country. Another factor was the annual port dues, which exceeded all others apart from London, Bristol, Liverpool and Hull. The influential merchants of Lynn formed an alliance, putting up a spirited localised defence. However, their stagnation was somewhat alleviated when steam ships took over from the slower sailing boats. Two new docks were built to capture the trade, and huge sheds, warehouses and grain stores were erected. Railway lines were laid right up to the quayside. All this

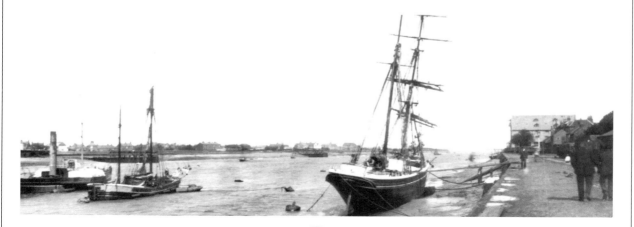

displaced the very last wooden sailing boats.

Silt has always been a problem at Lynn, and in November 1889 a 1193-ton bulk maize cargo ship went aground, breaking her back. Local fishermen did well by removing much of her cargo. After several unsuccessful salvage attempts she was abandoned, creating unease that this would affect the silting-up even more. It is not recorded whether the ship was being piloted at the time; it was the Pilot Master's job to place the buoys and beacons at his own expense out of his excellent wage of £350.

The Bentinck Dock was opened on 4 October 1883 by J Cavendish-Bentinck, from whom it was named, and it was connected by locks to the Alexandra Dock, which was opened on 7 July 1869 by the Prince and Princess of Wales. The steamers that used the docks had familiar names, such as the 'King's Lynn', the 'Sandringham', the 'Hunstanton' and the 'Middleton'. Timber and grain trade increased so much that twelve miles of extra railway lines with turntables had to be laid.

Sandringham House

Sandringham was bought for the Prince of Wales (later Edward VII) and it has been home to four generations of sovereigns. Originally a Georgian structure, it suffered a bad fire in 1891, and it has gradually been expanded since then. The Royal Family spend their Christmas here, and it is their official base until February each year. On 14 December 1895 George VI was born at Sandringham; he died there on 6 February 1952. It was a sad day for the local population and the world's media as they watched the royal train leave for London from Wolferton station.

Sandringham House was first opened to the public in 1977; there is a museum of the life of the Royal Family and the history of the estate. It is a commercial venture, managed by the Queen's Agent, and over half of the land is let to farm tenants; the rest is used for forestry, fruit farms, a country park and studs. Including the gardeners, over a hundred full-time staff are employed here. Sandringham Country Park was opened in 1968; it has over six hundred acres of woodland and heath with nature trails, and it is free to enter. You will have to pay, however, to stay on its camping and caravan sites. During the year there are many country shows and craft fairs.

Seven villages make up the Sandringham Estate. The villages are all full of charming cottages made of local carrstone and flint, with well-kept gardens. In particular, Wolferton has its historical royal connections, which involve the quaint railway

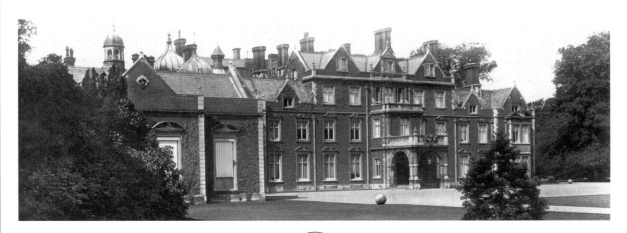

station and stud; but it was also important as a producer of salt when the marshes were reclaimed and drained. Farming in this area is typical of East Anglia, producing cereals, beef and milk, vegetables and the famous Norfolk lavender, which adds a splash of colour and delightful scent to the countryside.

Manufacturing, Arts and Sciences

Lynn produced three of the country's greatest engineers: Frederick Savage, Alfred Dodman, and Thomas Cooper. Savage's traction engines can still be seen at farm shows and fairs, and there is no doubt that most children have ridden with glee on one of his funfair roundabouts. There is not enough space here to list a fraction of Savage's pioneering products, but it is safe to say that his efforts revitalised Lynn's industrial strength. He deserved the statue which was erected before he died in 1897. Dodman and Cooper produced cars, plane engines, boilers and ball-bearings – the Jodrell Bank telescope runs on these.

In 1913 Lynn launched its society of Arts and Sciences. The town now has a wonderful and famous annual music festival.

The Great War halted the town's progress, and in 1915 a Zeppelin bombed and killed two people.

After the depression, Lynn was badly affected by the Second World War: over one thousand Lynn men were in the forces, and over two thousand seven hundred evacuees were taken in by already over-stretched families. In both World Wars, Lynn was lucky not to receive heavy bombing; but in June 1942 a bomb did demolish the Eagle Hotel, killing forty two people.

With the town being surrounded by fertile farmlands, it comes as no surprise to learn that manufacturers in food processing became big employers in the area. Every fruit and vegetable was grown close by; hundreds of jobs in the fields were provided for those with strong backs, including part-time employment for students from home and abroad during their term breaks. Vast commercial expansion took place during the 1950s. The distinctive Campbell's Soup factory alongside the busy A47 was a landmark. Frozen foods and meals were produced and housed in Britain's largest cold store, which was owned by Fridgoscandia.

Products from famous brands such as Jaeger, Wedgewood, Dow Chemicals, Porvair and Mars UK Ltd were made or distributed from Lynn. These and other companies created jobs for thousands of people, the majority of whom came here in as overspill from London.

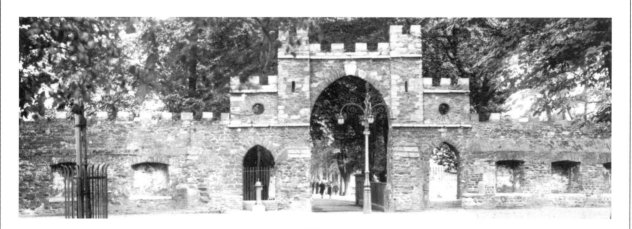

The Town Develops

In the great flood of 1953, Lynn was virtually covered by six feet of water brought on by a combination of freak storms and high tides, which burst through the sea defences. Over one hundred people lost their lives; but with the wartime spirit of the British character, everyone co-operated in cleaning up the town afterwards.

For years, especially at Christmas time, the town and its station have seen the arrival and departure of members of the Royal family on their way to and from Sandringham. They have also been regular visitors into the town not only in times of crisis like the floods, but also to meet the staff and employees of the increasing number of factories. They support local traders - the proof of this is the number of businesses with 'By Royal Appointment' signs in the town. The Queen Mother was the first woman to receive the Freedom of the Borough on 26 July 1954.

Slum clearance and town expansion took place in the 1950s, and new estates, schools and shops were built. Unfortunately, this regeneration programme cleared away a considerable amount of Lynn's early heritage, including a 17th-century building associated with the famous Vancouver family.

The Way Forward

Norfolk is known as the bread basket of England. Its farmers have always been one jump ahead: they pioneered the development of sugar beet as a main crop, and supply a huge factory built in South Lynn on the banks of the River Great Ouse.

After a slow start through lack of funds, Lynn has come through times of great upheaval. So-called

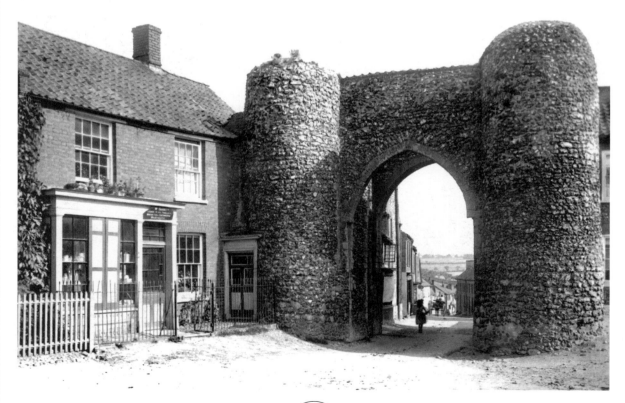

improvement programmes may have destroyed a great deal of its heritage, however, if we leave our cars and walk through the town, looking closely at the buildings above the well-known shops, we will see some beautiful early Victorian facades, some covering medieval buildings. There are still many older and well-restored buildings of great importance to be seen in Lynn. Their Dutch-influenced brickwork, jettied frontages, timber gables, carved doors, huge pillars, and courtyards all shout of the wealth and prosperity of the merchants. All this takes us back to a time when Lynn was one of the most important places in Britain.

Traffic-free areas enable us to walk around the parks and the waterfronts; the town's shops are very busy. The ports and docks are now active again with varied cargoes. The planners are making a much better job of retaining the splendid old buildings, and of creating more work opportunities for the population - which has increased steadily since the 1960s.

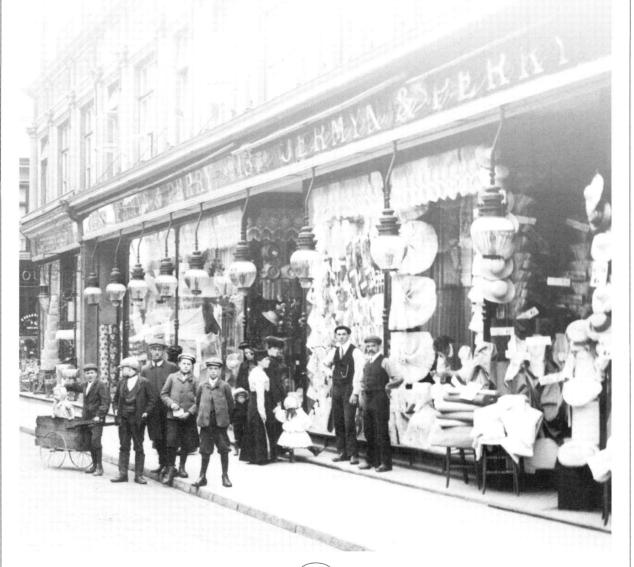

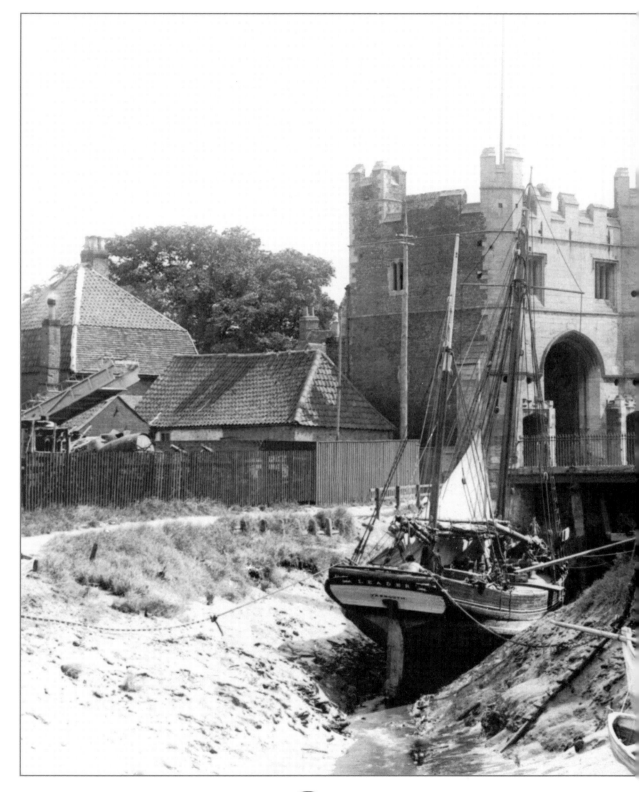

King's Lynn

South Gate 1891 28760
Presenting a fine entrance to the town, this handsome tower of brick and stone was built in 1502. Noble folk in their carriages would use the centre archway while looking down on lesser mortals who had to walk through the small arches. Fishermen living in this part of Lynn could just about navigate their boats back to base in this rivulet.

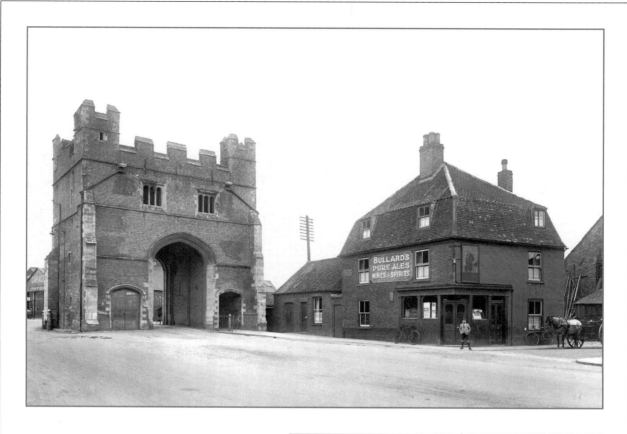

South Gate 1925 78716
This new, wide and normally busy main London road brought more houses with it. The boy may be earning pocket money by guarding the local customers' vehicles - bikes and a horse and cart.

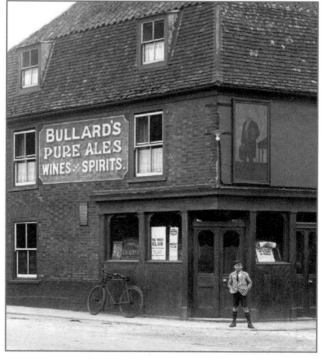

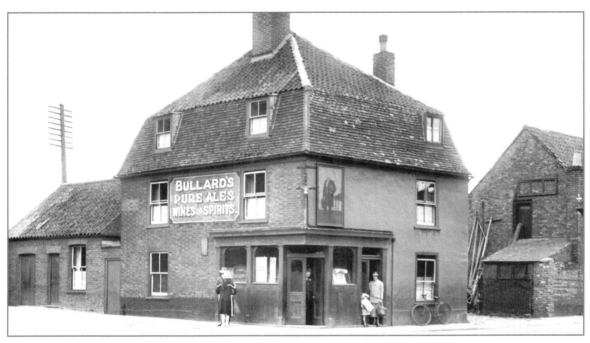

The Honest Lawyer Inn 1925 78717

It is not certain what the ladies in the picture are up to, but Lynn has a significant history of brewing, and it was considered at one time to have had many pubs of poor reputation. The licensing act of 1902 tidied things up.

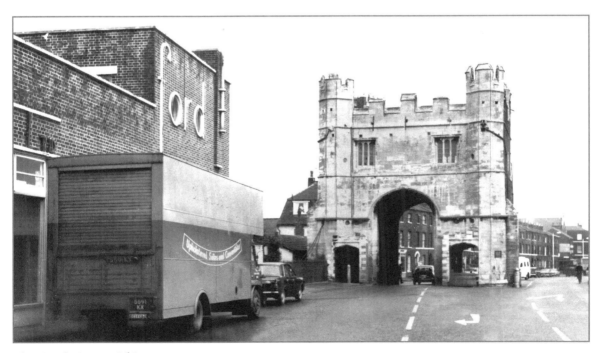

The South Gate c1965 K28116

William H King is the main dealer supplying Ford products. His garage is situated on the main London road, which passes through this important southern entrance to the town.

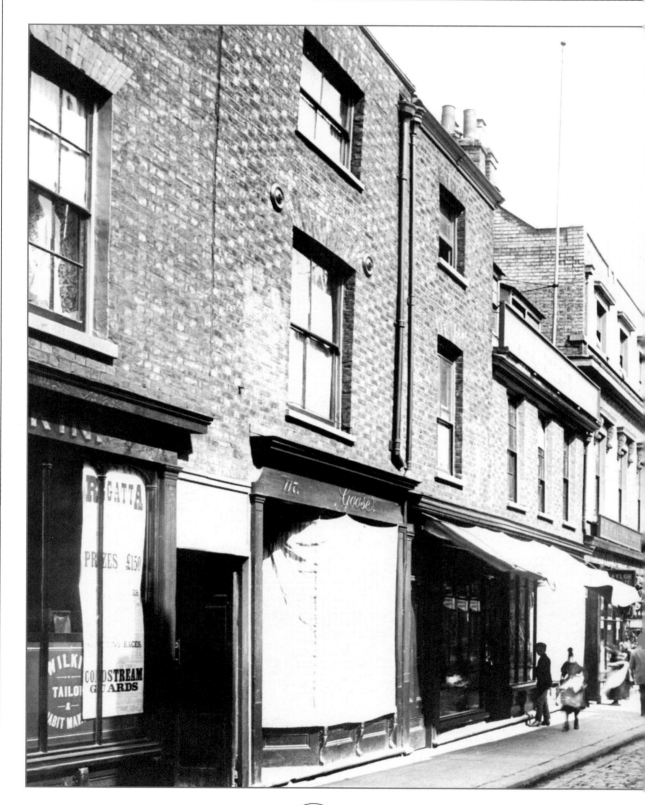

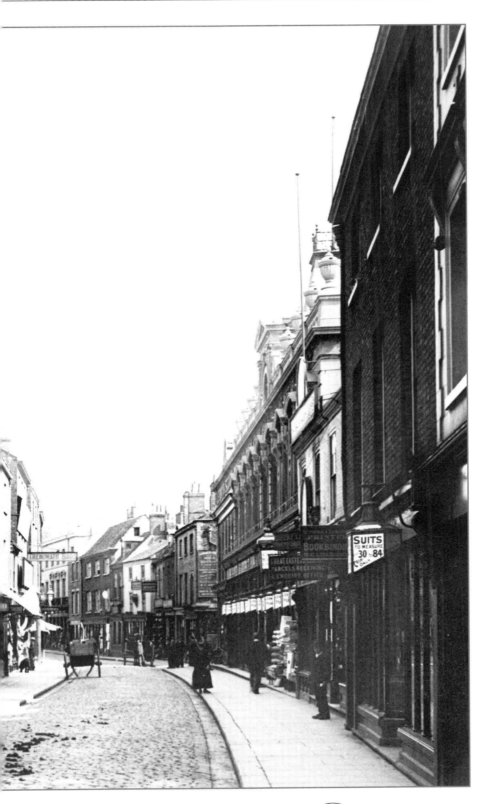

High Street 1891
28770

Department stores are just emerging, and shopping is already very competitive. Large front windows were installed, and upper floors had smart interiors. James and Sarah Goose (left) were still selling exclusive millinery and drapery, but the local rich families liked to be seen in larger establishments. Wilkins the tailor (left) had moved from Regent Street, but could not compete, so he was forced to sell theatre and regatta tickets; John Wingate the book binder had to sell patent medicines and start a circulating library. The lower classes did not shop here, and it is surprising that the horse droppings in the street were not quickly disposed of.

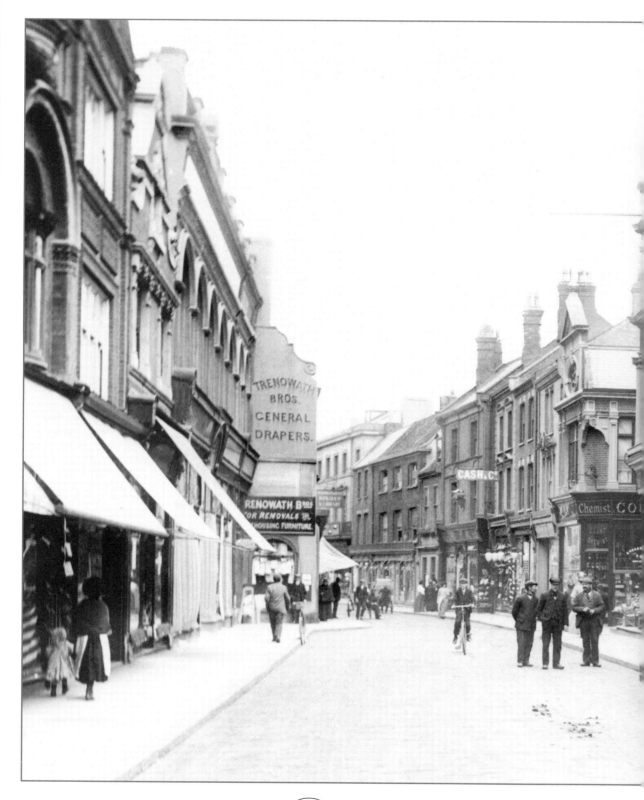

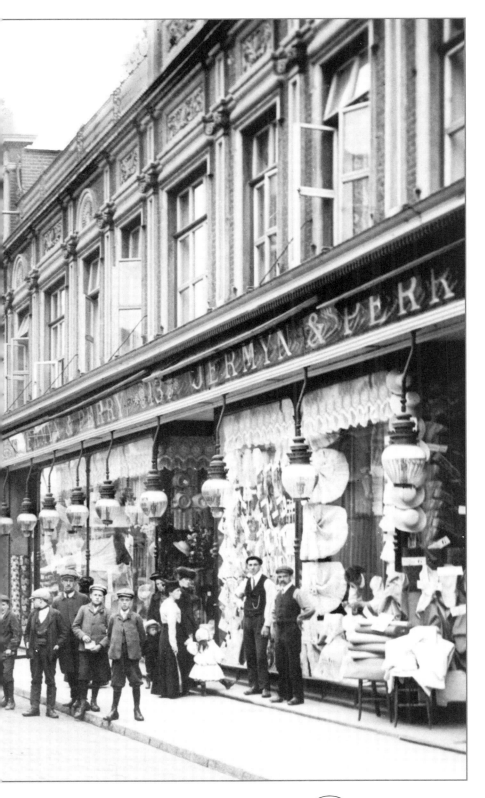

High Street 1908

60023

After removing his sister, the boy with the cart will collect the horse droppings from this very respectable street. Cash and Co (centre) supplied the footwear worn by the twin boys in the foreground. Trenowath Bros, general drapers (left), diversified into cab making, upholstery and removals because they could not compete with the early department store Jermyn & Perry. Alfred Jermyn (later Sir Alfred) established his first business in 1872, and was later joined by the draper Perry. The shop was burnt down in 1884 when an assistant set fire to the Christmas decorations: the fire took hold because the Lynn fire engine had broken down. There was another fire in 1897, started by a careless person lighting the 220 gas jets on Boxing Day. The store in the picture, rebuilt from the ashes, was in every respect well ahead of all its opposition.

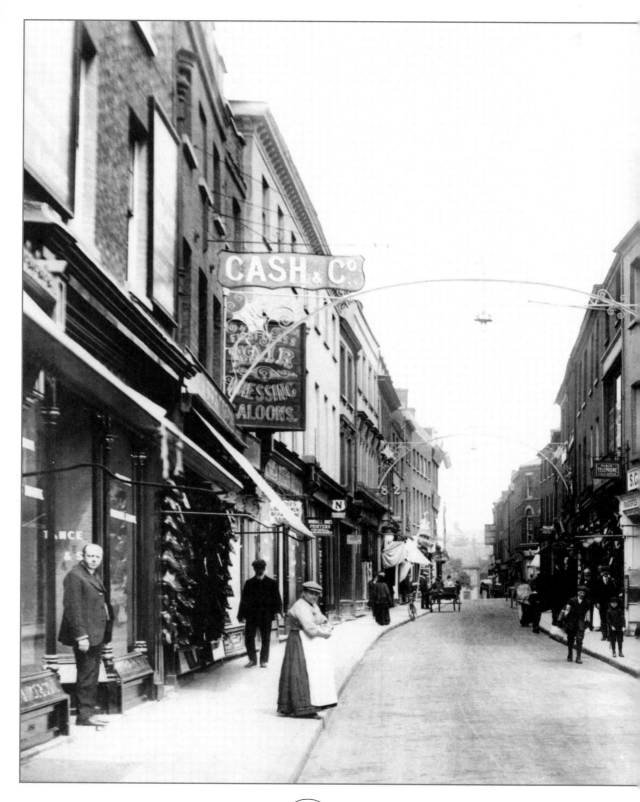

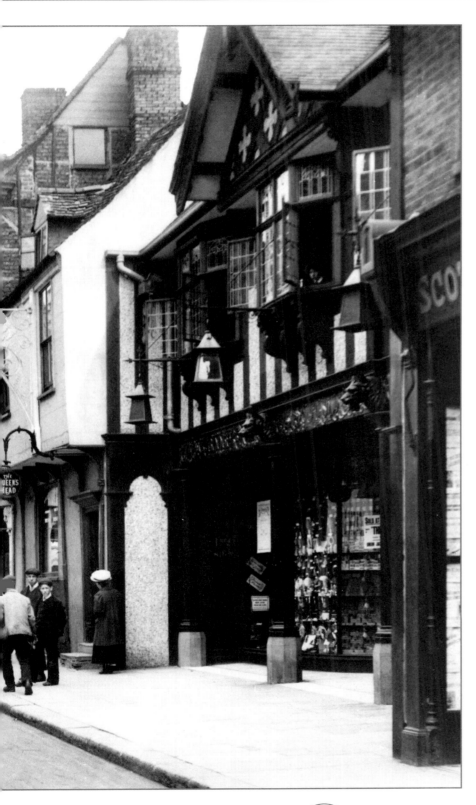

High Street 1908

60024

Mary Street's shop is on the right, where she dealt in pianos and other instruments; she also gave lessons at 2s an hour. Opposite and a little further down was J H Ladyman & Co, where Lord Nelson's surviving brother was a customer. In their own factory they produced sweets, jams and hams. Here you could buy eggs for 1s a score, sugar for 2½d a lb, and salt for 2s a ton. This shop was also known as Bunkall's after J T Bunkall, a senior manager of Ladyman's, who acquired the business.

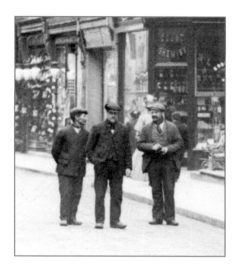
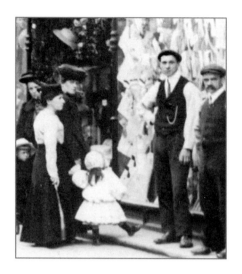
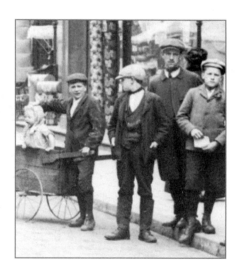

High Street 1908 60023 & 60024

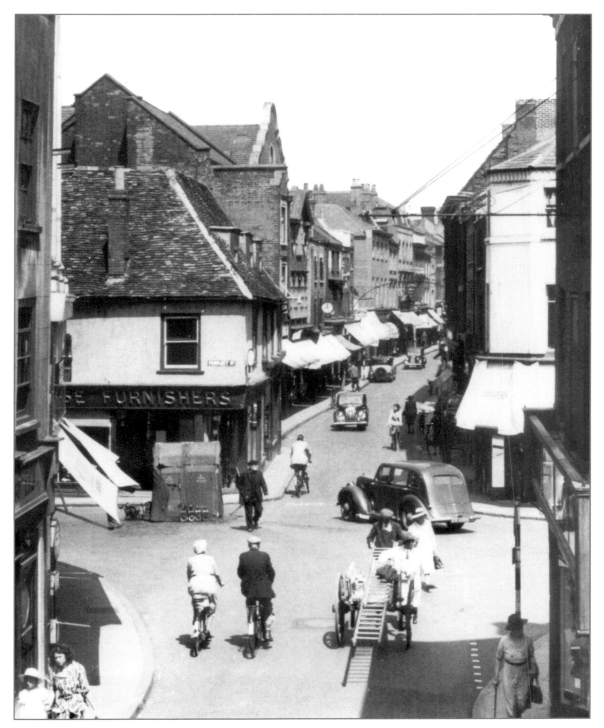

High Street c1955 K28035

This photograph shows an unusually quiet day for this street, where traffic normally has to avoid shoppers spilling into the road. Most of the well-known shops and banks are found here: the premises of the local firm Scotts Furnishers was established in 1874. The building was later demolished, and the site was occupied by Boots the chemist.

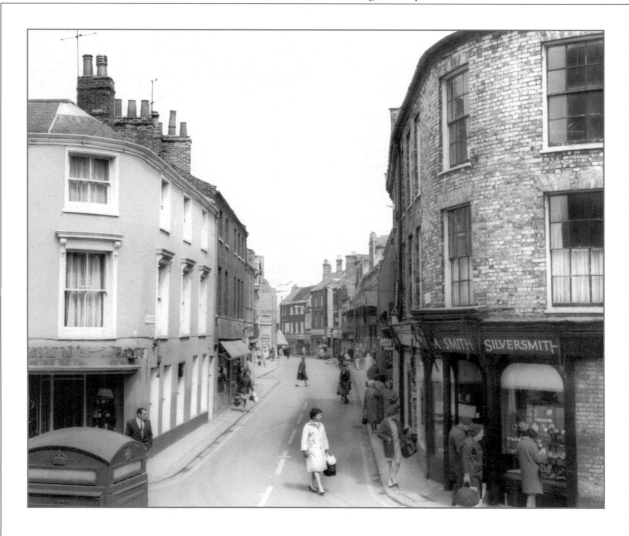

High Street c1965 K28120
The upper floors of the few remaining Victorian buildings have
retained their original façades. A Smith's jewellery shop is in a
house built for John Thew, founder of The Lynn Advertiser in
1841. His products seem to be attracting attention, even from
the man leaving Wenns Hotel on the opposite corner. Most well-
known names such as Dolcis, Smiths and Purdys had their
premises further up the street.

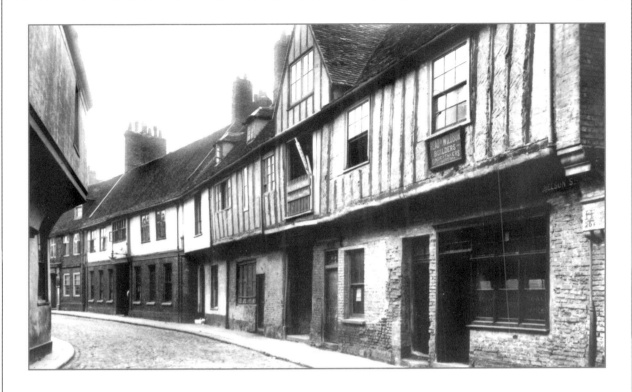

Nelson Street 1908 60025

Napoleonic prisoners laid the granite cobbles in this street. John Hampton, a master baker, lived in the first house on the right, one of his famous products were ships' biscuits that travelled the world - often accompanied by weevils. If we enter the courtyard on the right, immediately under the balcony containing Read & Wildburns building rods, we will find a wonderful quadrangle called Hampton Court. This was an addition built by the Ampfles family in the late 15th century, and their mark is carved into the courtyard entrance. There is a cannonball suspended from its ceiling, which is said to have smashed through St Margaret's Church west window during the siege of Lynn.

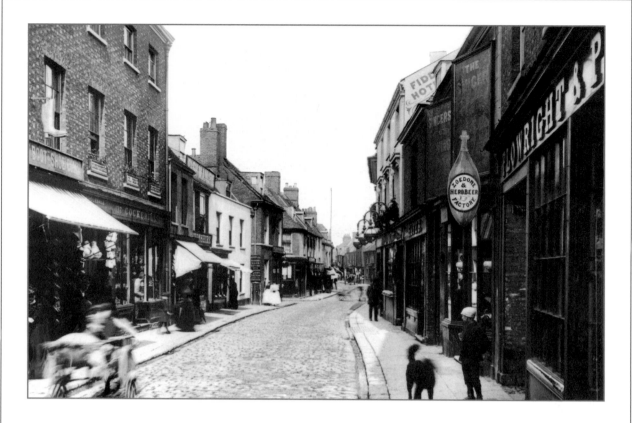

Norfolk Street 1891 28769
The barrow boy is going as fast as he can over the cobbles,
delivering smelly fish manure from Taylors the seedsman. You
could buy everything in this street: fine china and glassware from
Elizabeth Cockerills, herb beer from Zoe Dome, and hardware from
Plowright and Pratt. Fiddermans Hotel had a magnificent carved
snooker table made for Edward VII and shown at the Paris
Exhibition: it was purchased by a Spalding hairdresser when the
hotel was demolished.

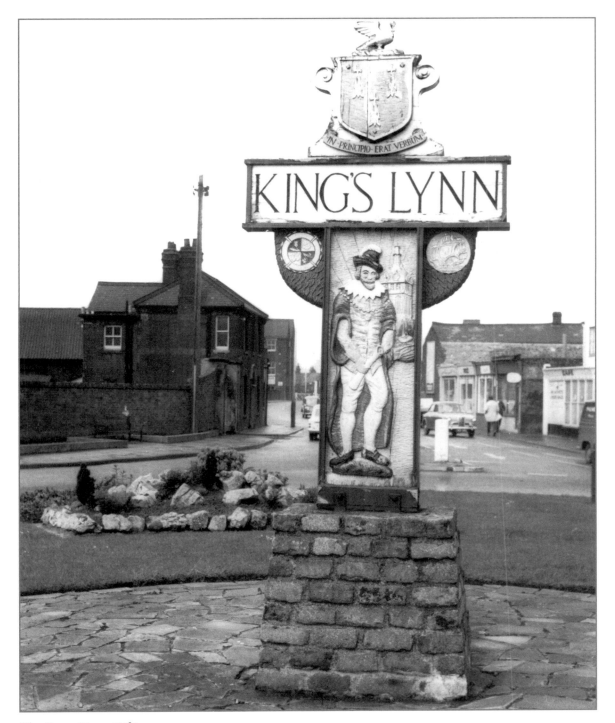

The Town Sign c1965 K28115
Made in English oak by Harry Carter of Swaffam, the sign weighs 5 cwt. Under the borough crest stands Henry Bell, one-time Mayor of Lynn, with the Custom House in the background. On the reverse side St Margaret overcomes the dragon of evil. The sign also shows the Admiralty seal and the crest of the National Federation of Professional Women's Clubs, whose local branch donated the sign.

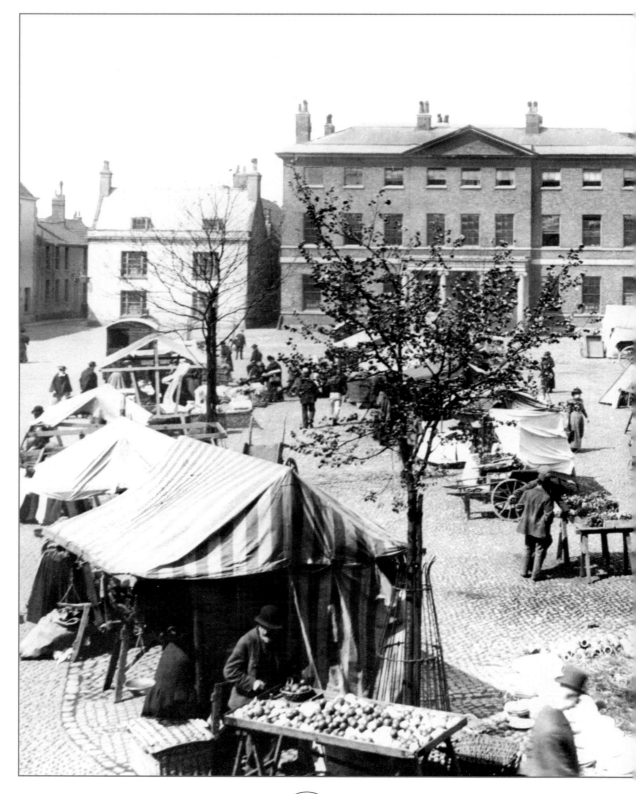

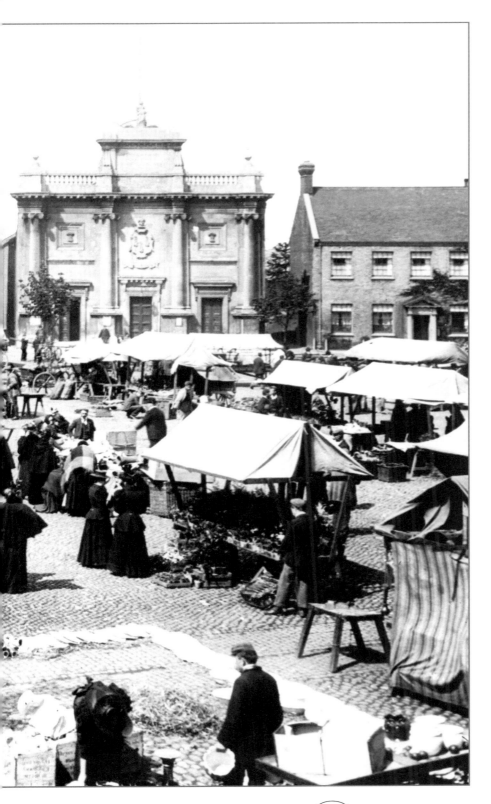

Tuesday Market Place 1898 40886
Markets have been held here since the 12th century, when farmers and traders from outside Lynn were allowed to come in and sell all kinds of produce and wares. Even a year after the Jubilee of Queen Victoria, most of the ladies in this photograph are still emulating her drab mourning dress; they seem to be talking, not buying from the covered stalls or shambles. The single lady in the centre has drifted in from the smarter side streets, and is strolling with idle curiosity. This cobbled market is spread over three acres and is surrounded by good houses and properties of great historical significance.

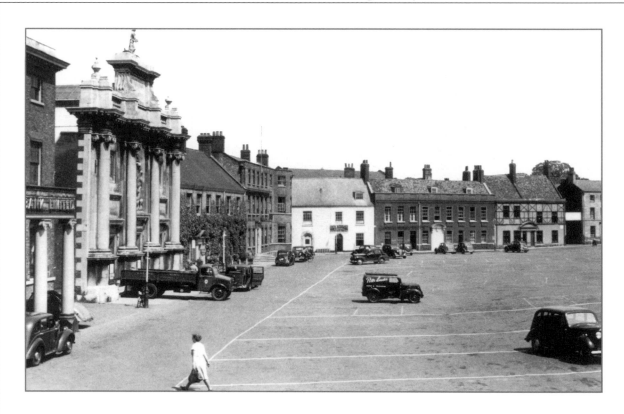

Tuesday Market Place c1955 K28037
This calm scene bears no resemblance to the hustle and bustle of activities
that have taken place over the centuries. All types of trading took place here.
Buyers arrived by boat, regular stagecoach and wagons from all over the
country and abroad. Huge fairs were held here. It was not all fun and frolic:
criminals and witches were subjected to the stocks, pillories, gallows and
gibbets and were boiled in oil. Barclays, on the left, is on the site of the first
Custom House of 1620. Next door is the Corn Hall, now a theatre. The
building with the flagpole is used by Thomas Sommerfield, shipbuilders; it was
the home of Mr Bagges, a wealthy merchant, who built a tower on the roof so
that he could spot his ships coming into port. Across the square is a mansion
with a white front door. Above this on the wall is a small carving of a heart
within a diamond: the story behind this is that a suspected witch named Mary
Smith was burned at the stake. Just before she died her heart leapt out from
her body and came to lie where the symbol can clearly be seen today.

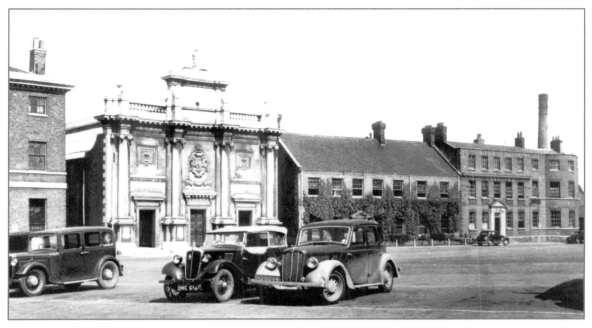

Tuesday Market Place c1955 K28016
Markets are held on Tuesdays and Saturdays in separate places. The classical stone building is the Corn Exchange, built in 1854. A statue of Ceres, the goddess of plenty, stands on the top overlooking this Tuesday market place, where criminals were punished. There was also an annual showmen's fair held here.

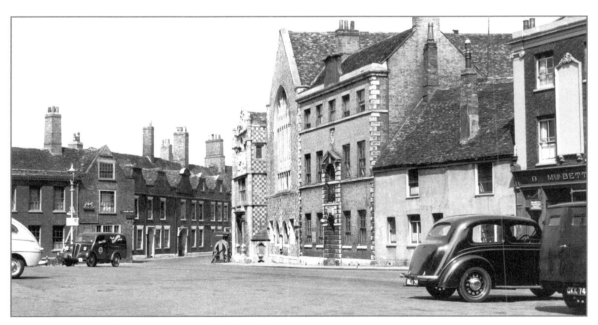

Saturday Market Place and the Guildhall c1955 K28025
This picture was taken from the market place, where fairs were also held on Saturdays, and still are. The Guildhall is the building with the large window; it was built between 1422 and 1428. The borough gaol of 1784 on its right was still a police station when this picture was taken. Mrs Betts had a successful furniture business dealing mainly in wardrobes (right).

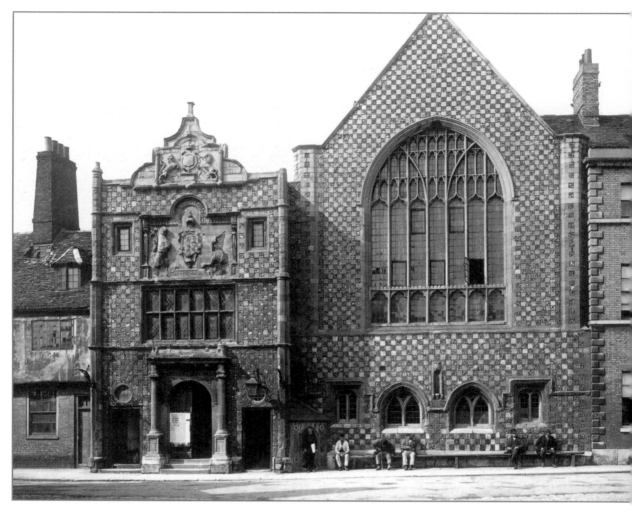

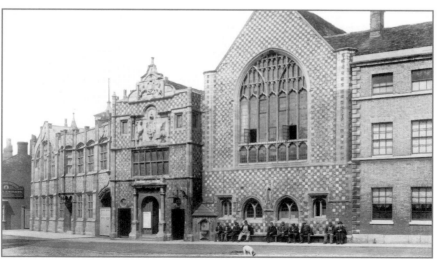

◀ **The Town Hall 1898**
40879
Next to the man on the left is a drinking fountain with an animal trough; there is comfort for the men using the seats, but none for man's best friend - having had a drink, he cannot find grass, trees or lampposts. On the left we can see the additional municipal offices which were built in 1895.

The Town Hall 1891

28754

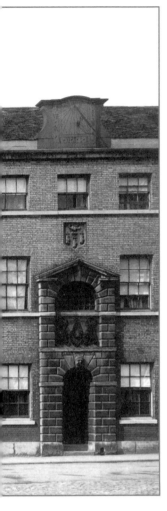

Authorised by an ambitious official, this building on the left of the Guildhall was added in 1624. The men seated on the benches are waiting to get a perfect view of sentenced prisoners being taken to the Town Gaol, which is on the right of the Guildhall. On top of its front door is a motif of fetters and chains, identical to that of London's Newgate prison.

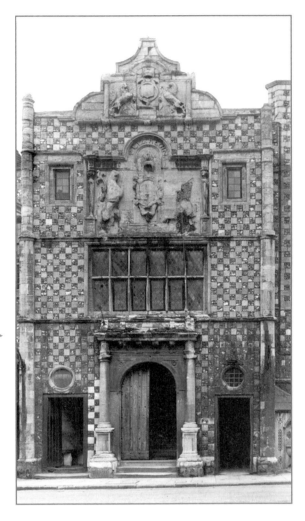

The Town Hall 1925 ▶

78715A

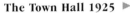

Above the arched door and the handsome square window are the remains of the arms of Queen Elizabeth I, which were removed from St James' Church on 7 August 1624. On top of the façade are the arms of Charles II, added forty years later.

The Town Hall c1965

K28062

The Union Jack flag is only hoisted on royal birthdays or national occasions. The gaol's sundial shows 11am; the light is good enough to show the squared Brandon flint and stone in all its glory.

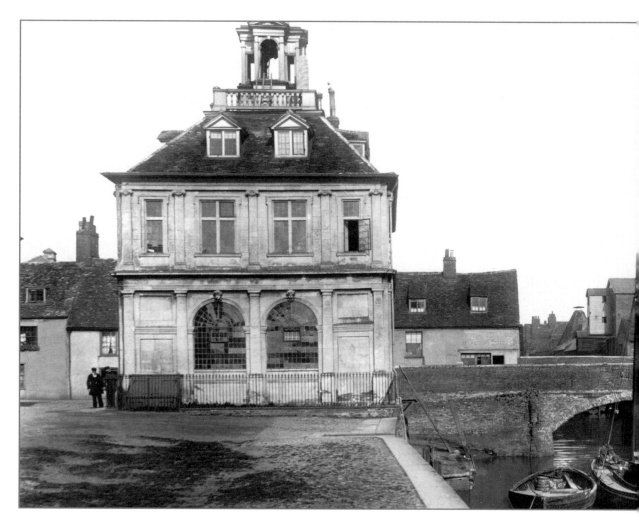

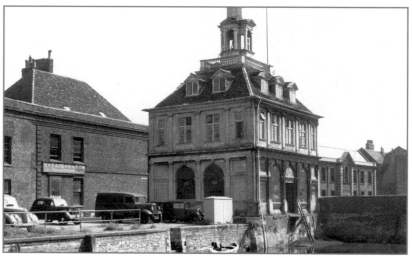

◄ The Custom House c1955
K28018

The house on the left, occupied by R W Fayers & Son, builders, was the home of Sir John Turner, who built The Custom House. His front door originally faced the entrance to The Custom House and as Sir John wanted to see his Regent every day, he had a statue made of him and placed above the entrance door. John Jasper Vancouver was deputy of The Custom House in 1748. There is a statue of him on the quayside. His son, Captain George Vancouver, gave his name to Vancouver in Canada.

The Custom House 1898
40878

Built in Ketton stone and opened in 1685, this famous building (by Sir John Turner, based on a design by Bell) was shared by merchants dealing on the lower floor and HM Customs on the first floor. Outside the entrance, a strict-looking customs official is keeping his eagle eye on the photographer as well as on the fishing boats, which were often used for smuggling tobacco, wines and spirits.

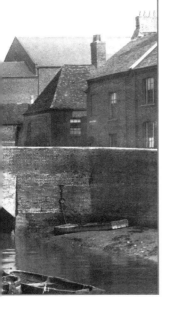

The Broad Walks 1891 28756

The first avenue of trees was planted in the park during 1753. In the 19th century, fungus started to attack the elm and ash trees, and in August 1891 an ancient mulberry tree planted by monks from Blackfriars Monastery blew down. Flowerbeds have been planted where some trees once grew.

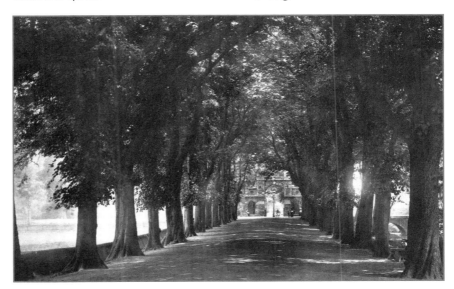

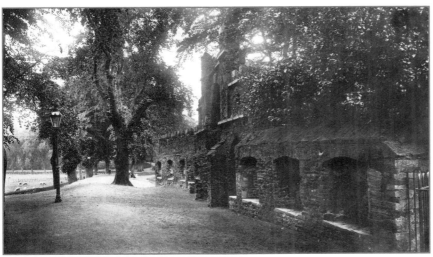

The Walks, The Old Town Wall 1891 28758

Fit men who were claiming poor relief provided the labour which helped to redevelop The Walks. This area dates back to the Middle Ages. This gate was manned for almost twenty-four hours, and was used to collect tolls from visitors and merchants on their way through to the town. During the Black Death, it was locked at night in an attempt to keep out unwanted criminals or those who it was thought might be carrying the plague.

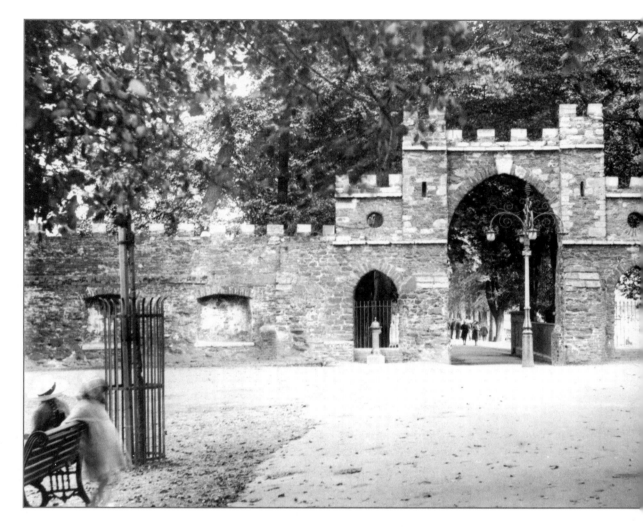

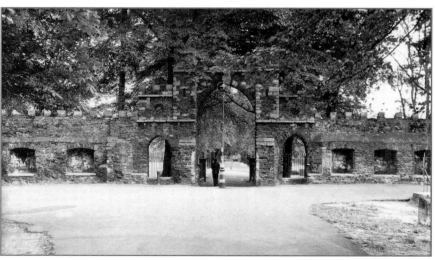

◄ **The Walks, Archway c1955** K28012
This archway and wall date back over two hundred years; it is known as Gannock Gate, and forms part of a huge park known as The Walks, where it was the perfect place for fashionable folk to promenade in the time of George II. Over the years The Walks has been continually extended with avenues and trees, providing a welcome open space in this part of town.

The Roman Arch 1921
71056

The schoolgirls on the left are happy to make their own amusement, while watching their parents promenading through the entrance into the extensive parks known as The Walks.

The Archway, Broad Walk c1965
K28107

We have two items of interest in this picture: the archway, the Gannock Gate, and the Red Mount Chapel behind the trees on the left. The Gannock Gate is made of stone and brickwork, and the greater part is of modern workmanship. The gatekeeper in ancient times would have been a significant member of the community. He would be armed with a heavy club; part of his duties was to check on vagrants and strangers, who would not be admitted unless they could give a good account of themselves.

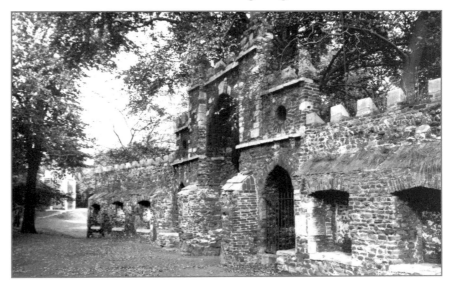

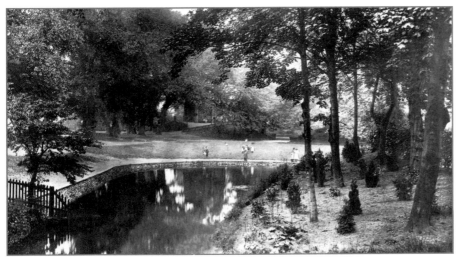

The Walks 1891 28757
This is one of the delightful riverbank areas, providing shade and shelter for those enjoying a stroll or picnic. In a severe winter, the river provides good ice-skating conditions.

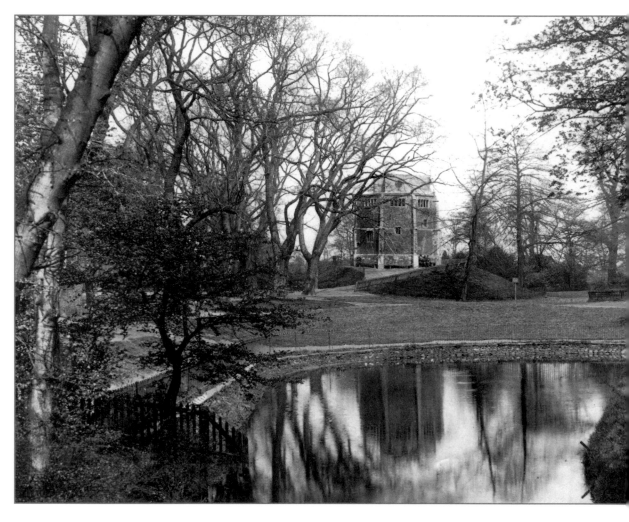

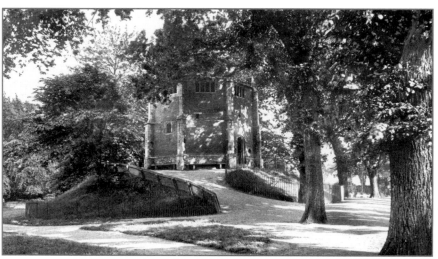

◄ **Red Mount 1891** 28755
Enjoy a leafy walk and
discover a unique
architectural experience.
Built in the 15th century
to contain a relic of the
Virgin, this building is
also known as Our
Lady's Chapel. This small
quaint building is said to
have been used by
pilgrims on their way to
Walsingham.

Red Mount 1898 40889
The chapel is enhanced by being set on a mound amongst the trees and rivers of The Walks; it deserves close inspection, as there is no other building of its kind in the world.

Red Mount Chapel 1898 40890
This winter view of the chapel makes it look like a prison rather than the fascinating building it is. Robert Corraunce built it on instructions from the prior of Lynn. It has an inner core divided into three stories, and around this core is an outer enclosing wall with a staircase in between. Above this there is a cross-shaped ashlar building in Ancaster stone. In this picture we can see new stone on the buttresses; they were repaired in 1809 by Major George Edwards.

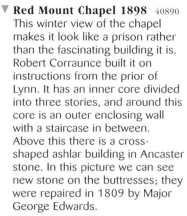

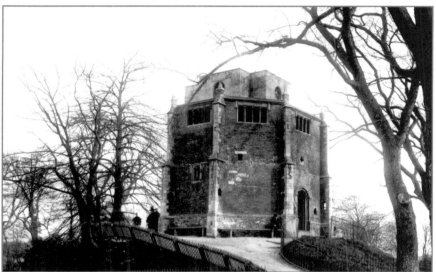

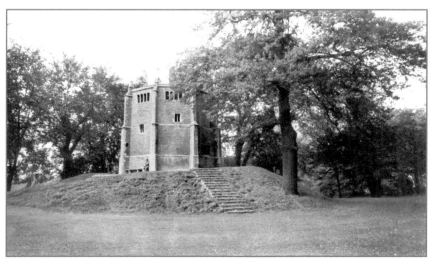

Red Mount Chapel c1965
K28106
This photograph of Red Mount Chapel was taken almost seventy-five years after 28755 (page 48). The chapel appears to stand on a sloping earth mound; but this earth covers a platform extending from the chapel base at the level of the entrance doors. In front of this main entrance is a window through which the worshipper can see underneath him the altar of the lower chapel. This is where we can appreciate the beauty and fine proportions of this tiny but perfect church.

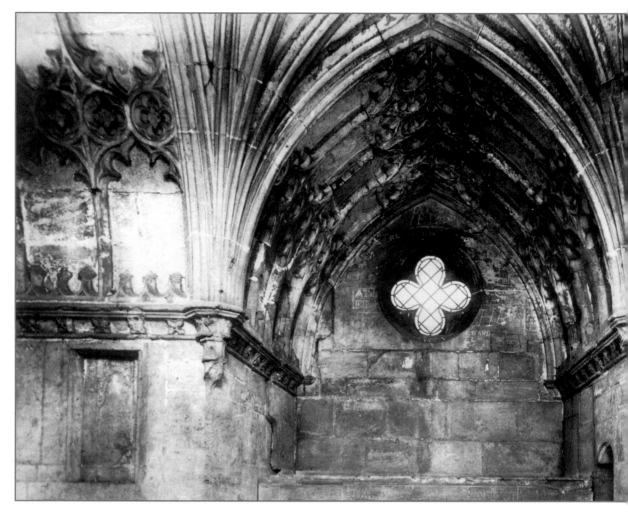

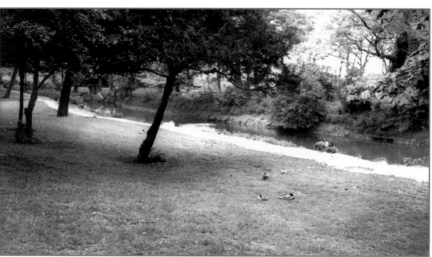

◄ **The River**
The Walks c1965 K28117
The river meanders through the grounds and beside the flowerbeds of this park, which adjoins The Walks. This idyllic scene covers a grisly history: this area was a burial ground, which was frequently robbed to provide bodies for the science of anatomy.

Red Mount Chapel 1898 40891

This picture shows some of the beautiful internal carved work of Red Mount Chapel, which is said to compare with that of King's College Chapel.

All Saints Church ▶ South Lynn 1907

57220B

Mostly 14th-century, this church has good carvings. All Saints has 11th-century origins, and the 12th- and 13th-century rebuilding is still evident. There are remains of a painted rood screen, and one of the best examples in the country of an anchor-hold, or anchorite's cell, where women hermits lived. We can see this on the south side of the chancel; it has a window looking through to the altar. The church tower collapsed in 1763.

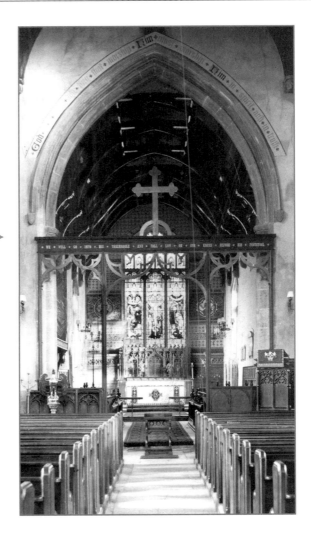

◀ St Margaret's Church 1891

28761

Called the shambles, this aptly-named rectangular building was built here for the town's merchants, who used their influence to get the necessary permission. The first floor contained a school, and underneath it was a butchers' market - we can see their tables and stalls leaning against the walls. The Georgian shambles was demolished in 1914 so that vital repairs could be carried out to the north porch of the church.

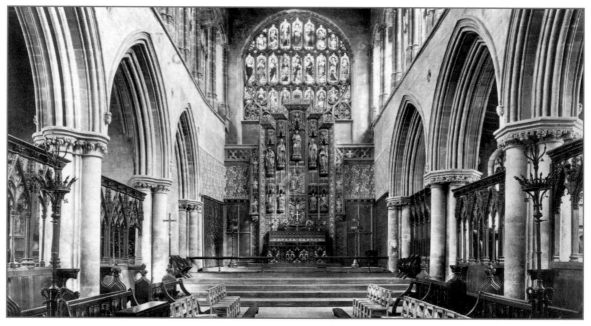

St Margaret's Church 1891 28763
This chancel is full of spectacular stone carving; the arches have deep-cut mouldings, and their quatrefoil column clusters have capitals carved in the stiff leaf style. The east window is an unusual circular design, containing brilliant stained glass.

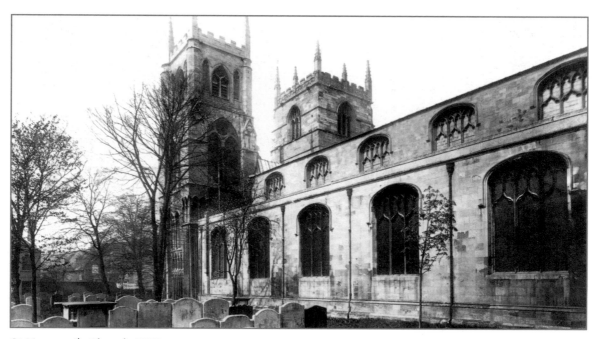

St Margaret's Church 1898 40882
These beautiful stained glass windows showing scenes from the New Testament are on the south side of the church. Also here is the Benedict Chapel, whose altar stone rests on a stand made of the old pinnacles that were once on the tower.

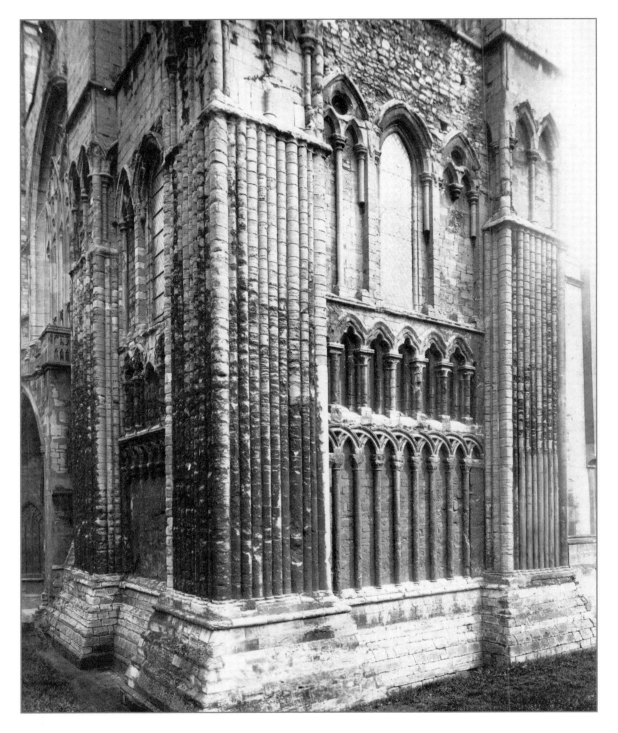

St Margaret's Church, The West Front 1898 40883
This west front tower is clearly different in architectural style from its
partner in that it has the original Norman reeding on its corners.

St Margaret's Church
Base of the West Tower 1908 60026
Between the fine-reeded wall buttresses is Norman intersecting arcading. These curved and pointed arches indicate the arrival of a new style of architecture.

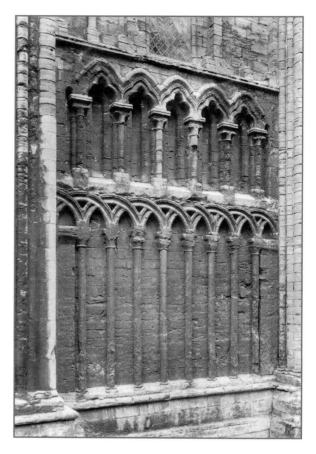

St Margaret's Church 1921 71059
The shambles building we saw earlier (No 28761 p51) has been demolished, and the town's beautiful church is revealed. The towers are clearly different, with two styles of architecture. Volunteers to wind the clock on the north-west tower were hard to find, so it is now electrically-driven.

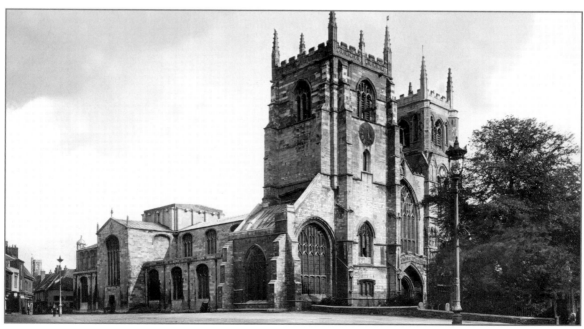

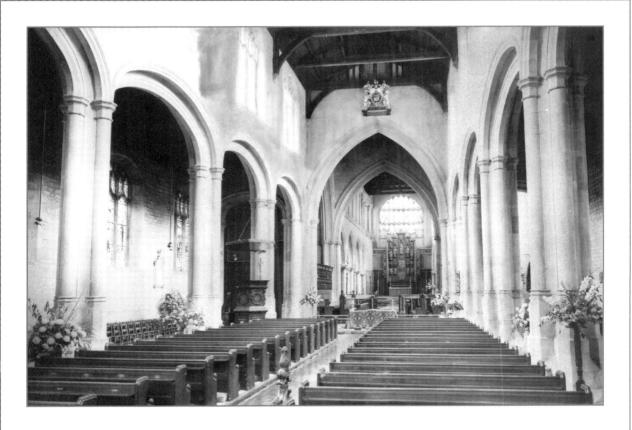

St Margaret's Church c1965 K28083
Above the nave is the Royal Coat of Arms. On the left-hand side is
the early Georgian pulpit with marquetry panels and tester. Behind
it is the organ, built by Snetzler in 1754 to a design of the organist,
Dr Burney, father of Fanny and friend of Mozart. It has the first
Dulcinana stop. Under one of the miserere seats which we can see
in the chancel at the back of the picture is a carving of the Black
Prince with his 'shield for peace'. On the right of the chancel are
the two largest brasses in Britain, dating back to 1349. One is of
Adam De Walsoken, and the other of Robert Braunche; the brass
also shows a peacock feast which he gave for King Edward III.

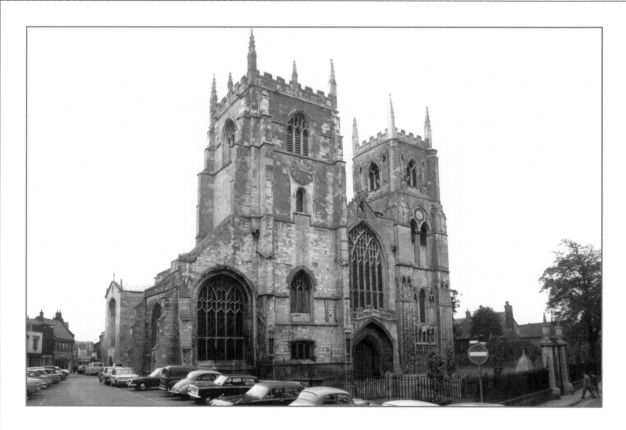

St Margaret's Church c1965 K28084
The moon clock on the right-hand tower was given by Thomas Tue in the 17th century; he was churchwarden and a clockmaker. The white central disc revolves and shows the phases of the moon, and it has a dragon which points to the time of high tide. This tower was built on poor foundations; it was rebuilt in 1453, and from the inside we can see that it stands at an alarming angle. But don't worry - it is good for a few hundred years yet.

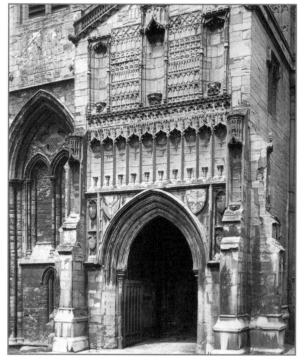

**St Nicholas' Church
The South Porch 1891** 28766
Creatures great and small can be seen here: lions, eagles, dragons, demons, angels and leaves, all sculptured above the canopies and shields on this beautiful porch. The door is made from solid wood and is finely carved, making this the most attractive part of the church exterior.

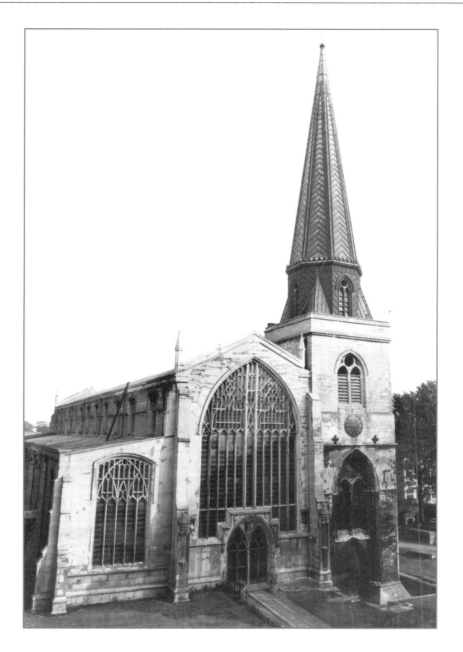

St Nicholas' Church c1965 K28112

Built in the 15th century on a slight hill on the site of a smaller building founded about 1160, St Nicholas' has a freestone tower containing 8 bells. This supports a spire erected in place of a much higher one which was blown down in 1741 by a great storm. The church once had fine misericords, which at a time of drastic restoration work found their way into the Architectural Museum in Jermyn Street. St Nicholas' contains the remains of Sir Benjamin Keene KB, born 1697, who was ambassador to Spain. This church is second in importance after St Margaret's, and its spire can be seen from most parts of the town. A huge number of the town's plague victims were buried here, and inside the church there are a large number of memorials to important merchant families. The fabric of the church was kept in excellent condition at considerable expense. In 1833 the Bishop of Lincoln confirmed two thousand children, watched by an enormous crowd.

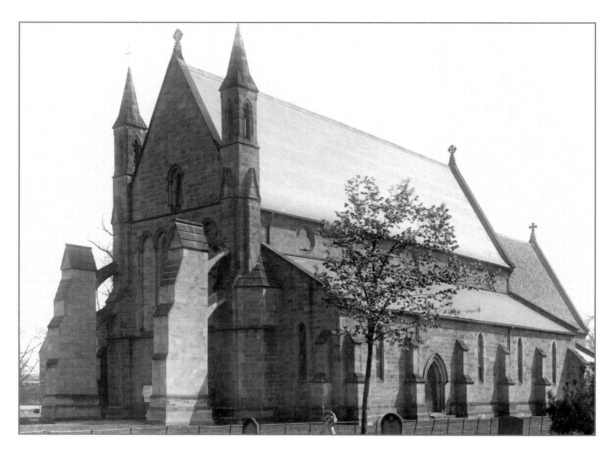

St John's Church 1898 40884
It takes strong arms to open the front doors of this
church. The key is 1 ft long and weighs 1lb 2oz.
St John's cost £5,000 to build; it is constructed in
Yorkshire stone, which was brought up-river by
boat. It was meant to seat over one thousand poor
people with no class barriers. The two exterior
buttresses were added in 1889 and cost £20.

Greyfriars Tower 1891 28768
This lofty brick hexagonal structure once formed the
central tower of a church built by the Franciscans.
Because it was so useful as a landmark for ships
entering the harbour, it escaped being torn down
after the Dissolution of the Monasteries.

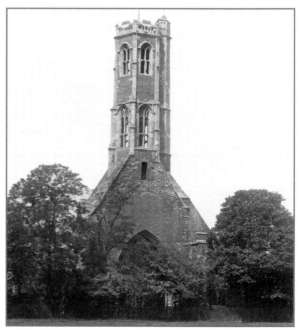

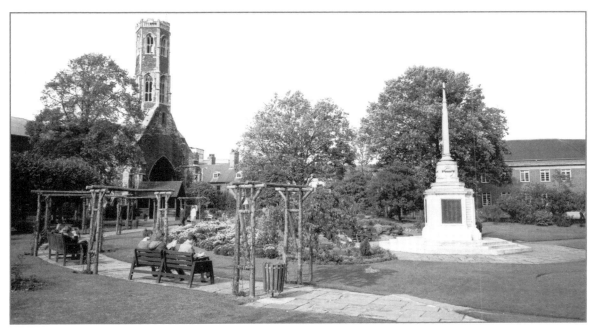

Greyfriars Tower c1965 K28103
This place of tranquillity is ideal for a lunchtime break, or just as a place to relax and reflect with gratitude on the sacrifice of those from the town who toiled for victory in the various wars which are depicted on the memorial cross.

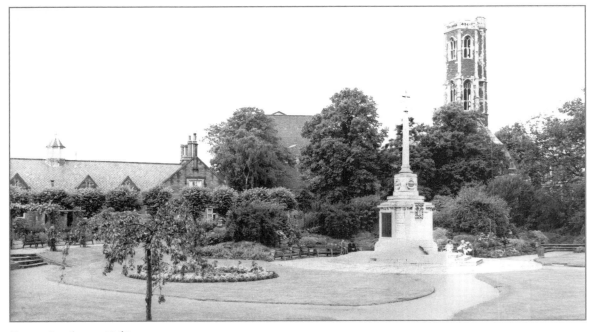

Tower Gardens c1965 K28068
In the grounds of Greyfriars are the Bank Lane arches. Previously, this part of Greyfriars had been used to house cattle and other farm animals awaiting market. The 14th-century arches were re-sited from Bank Lane near Ferry Street, an area demolished in 1910.

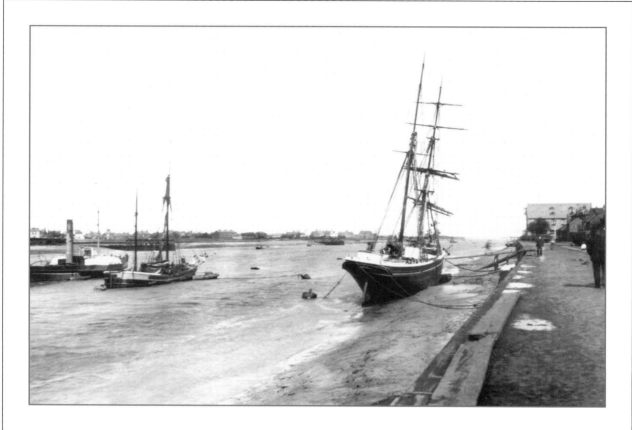

The Quay 1898 40893
The jetties we can see on the left of the picture forced the river current further eastwards, and since the 13th century they have provided a safe landing stage for ferryboats. The deep anchorage is bad because of the oozy silt on the riverbed. Mooring posts and blocks are deeply embedded in the quay so that ships can be tied up with strong ropes and chains. Steam-driven tugs came into their own, making a good living for their skippers by towing vessels in and out of the port in high winds and strong tides. A large number of sailing brigs were owned by master mariners who lived in the town. In its heyday you could walk right across the river on the decks of over three hundred ships moored along this quay. The two boats in the picture were made nearby on the river Nar, although this local shipbuilding industry finished in the 1860s when iron-clad steamships took over - these were too large to get into the port.

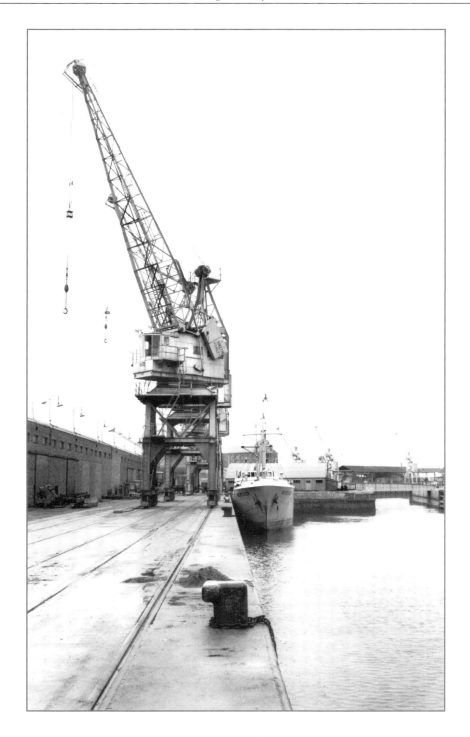

The Docks c1965 K28093
This is one of four Smiths cranes used in the port's smaller Alexandra Dock. It has a safe working load of 7½ tons. Moving on rails, it is powered by electricity from 440v sockets placed between the bollards. Clyde cranes, which we can see on the right, are more compact but lift similar weights.

The Docks c1965 K28092 ▶
This ship, HMS 'Breckland', was used constantly to dredge the various cuts and rivers, which always had a problem of silt.

▼ **The Docks c1965** K28094
It might look small in the centre of this picture, but in fact the spire of St Nicholas' Church soars above the high cranes. The 'Belvesiar', a cargo ship from Rotterdam, is in Bentinck dock, the port's largest. The timber in the foreground comes in from Scandinavia and Russia; regular sailings are made to and from Denmark, Rotterdam, Hamburg and the Mediterranean countries. Over two hundred workers are employed here, so this picture must have been taken before they started work or during a tea break.

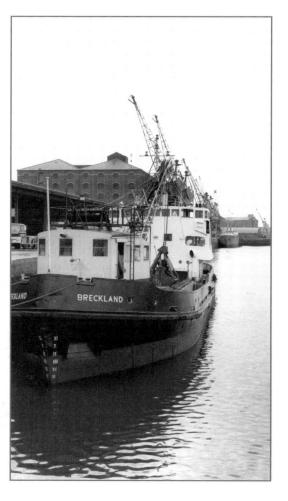

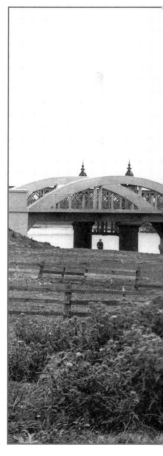

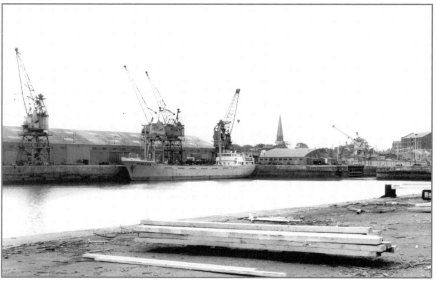

▲ **The River Bridge 1925**
78719
This bridge over the River Great Ouse was the gateway from the Midlands. Originally it was a timber toll bridge, which lasted from 1821 to 1873. This was replaced by a wrought iron lattice girder bridge on iron cylinders which, it was hoped, would last one hundred and twenty years, but forty-five years later it started to deteriorate owing to the fierce action of the river. The County Council took it over from the River Board, and the new bridge (now known as Freebridge) was completed in 1923 at a cost of £28,000.

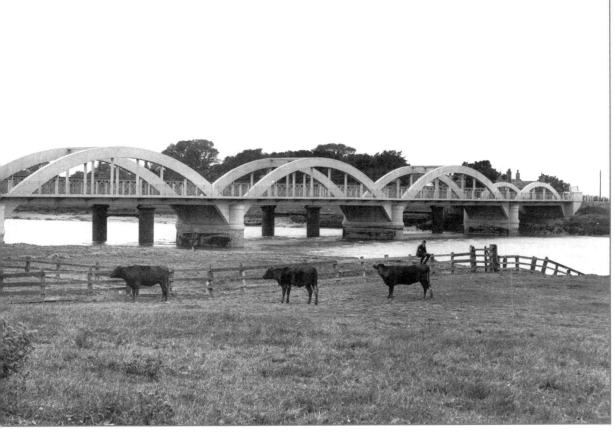

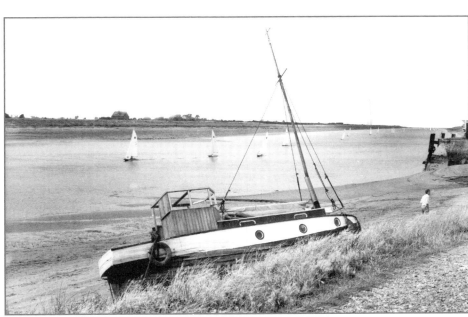

The River Great Ouse c1965 K28082 Gentle sloping banks made it easy for this fisherman to beach his boat for vital repairs. The sailing boats are having a good race on the low tide that has kept cargo vessels away from the dock entrance, which is just past the small building on the right.

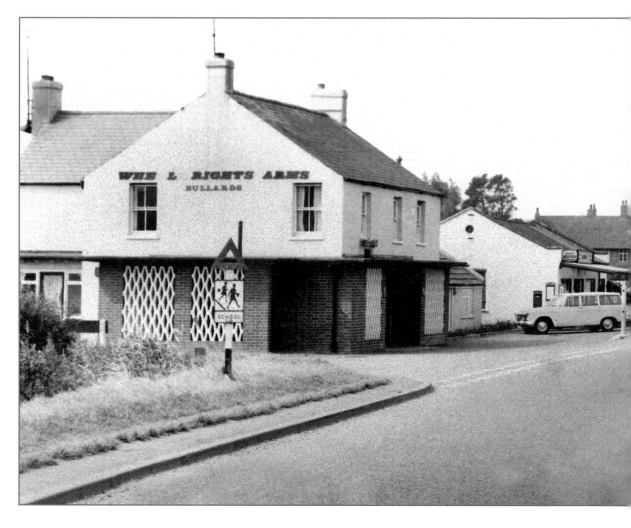

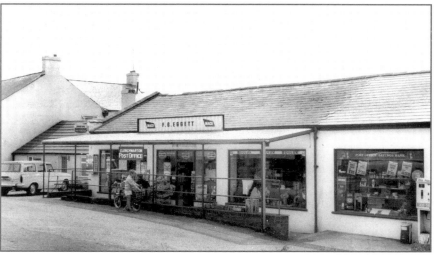

◄ **Clenchwarton
The Post Office c1965**
C416014
This busy shop was
previously the old village
hall, which was used for
dances, dinners and various
sales. Mr Eggett, known as
Gordon, prides himself on
obtaining most things his
customers want, even
drapery. There was a ladies'
hairdressing salon at the
back of the shop. It was the
duty of all his staff to keep a
watchful eye on the self-
service paraffin dispenser.

The Villages

◀ **Clenchwarton
The Village c1965**
C416011
What more does a
village need but a pub,
a shop and a church.
Little did Molly
Whitbred, landlady of
the Wheelwrights Arms
at this time, realise that
her pub would soon be
converted into private
homes.

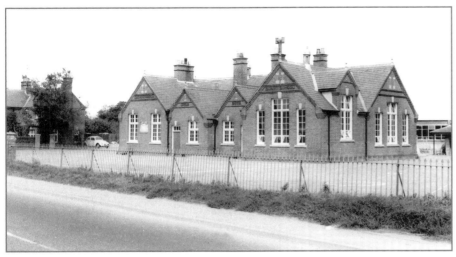

◀ **Clenchwarton
The School c1965**
C416015
Created in the 1870s,
these Board Schools
provided education in
towns and villages
where religious bodies
had failed to do so.
Boys and girls had their
own entrances into the
building, and were
always kept separate.

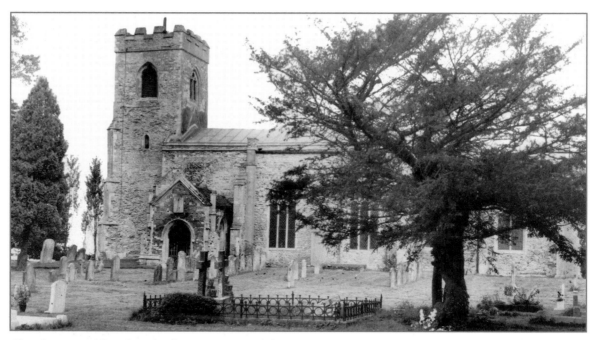

Clenchwarton, The Church of St Margaret c1965 C416001
This attractive Perpendicular-style church, with its battlemented tower, is unusual in having five bells, which are regularly pealed.

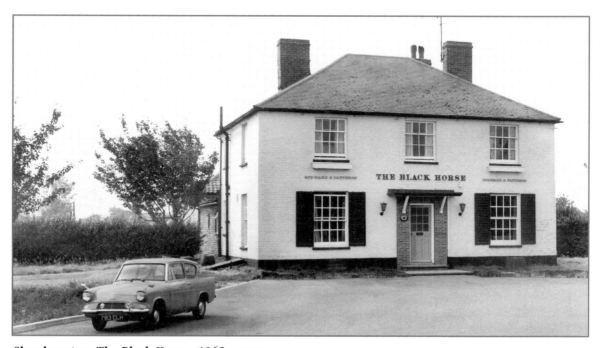

Clenchwarton, The Black Horse c1965 C416003
Now a free house, this pub is on the main road from Norfolk to the Midlands. It provides refreshment for locals, visitors and holidaymakers.

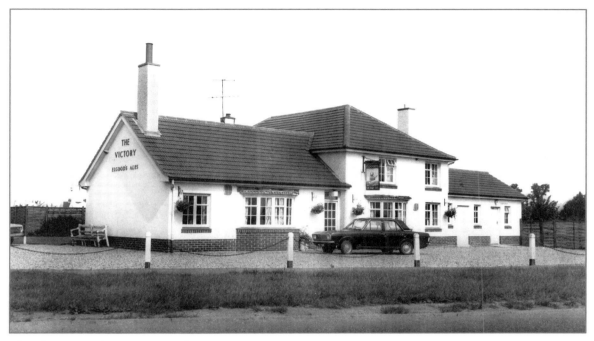

Clenchwarton, The Victory c1965 C416006
This public house serves the local residents well. Mrs Elizabeth May Leake MBE was the landlady since 1955 - she received her honour for many charitable activities. Mrs Leake's daughter has taken over as licensee from her mother.

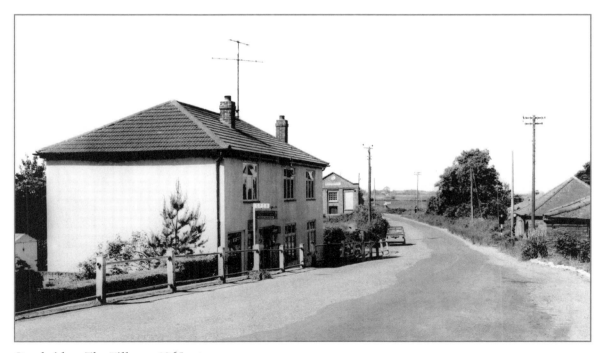

Stowbridge, The Village c1965 S689001
The riverside stores and post office is on the left of this picture. In the distance is the Bethesda Chapel, which is slowly subsiding and will need to be underpinned.

▼ **Stowbridge, The School c1965** S689003

Built in 1872, this church school charged two old pennies per week for every pupil. The house on the right-hand side belonged to the Headmaster, Mr John Bowden. Behind the school is a coach house where the horses and gigs were stabled. The school had two large classrooms which could be made into one, thus providing a dance and concert hall which raised money during the war to provide funds for soldiers.

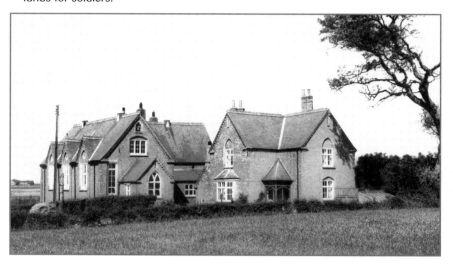

▼ **Stowbridge, Stow Corner c1965** S689011

This is the main street through the village leading to the railway station in the distance. The village has an interesting Chapel of Ease built in 1909. It is red in colour, and unusually constructed for the period - its wooden frame is filled in with clay blocks.

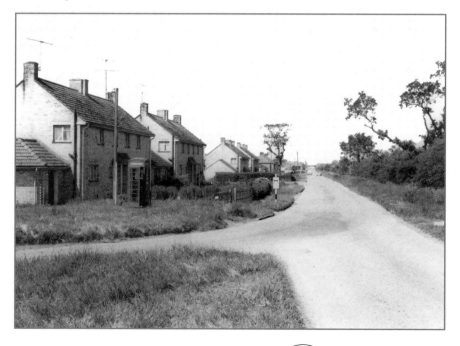

▲ **Stowbridge The Village c1965**

S689016

Taken from the bridge over the River Great Ouse, this picture shows the Crown public house on the right; it became a restaurant, and is now a Field Study Centre. Opposite is a barn owned by Wilfred Rolfe, which he used as a bicycle shop. The local 'Dad's Army' home guard brigade met in the barn during the War to plan their defence activities.

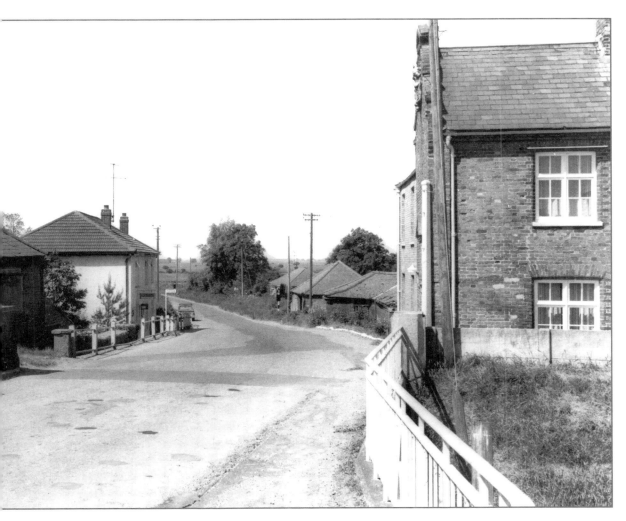

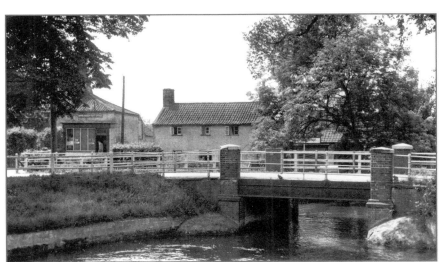

**◀ Narborough
The Bridge and the River
c1955** N189015
This bridge carries the main
A47 to King's Lynn over the
River Nar. The post office
and the cottage have now
been demolished, and the
village has been by-passed.
On the opposite side of this
road there is a huge water
mill and a trout farm.

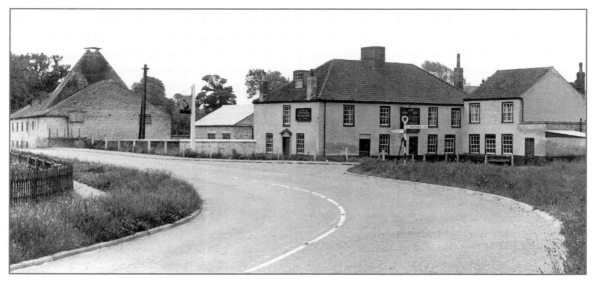

Narborough, The Ship Inn c1955 N189026
The Ship Inn still provides the locals and travellers who use this main road from Norwich to King's Lynn with good food and refreshment. The maltings (left) have closed down, and the premises are being redeveloped.

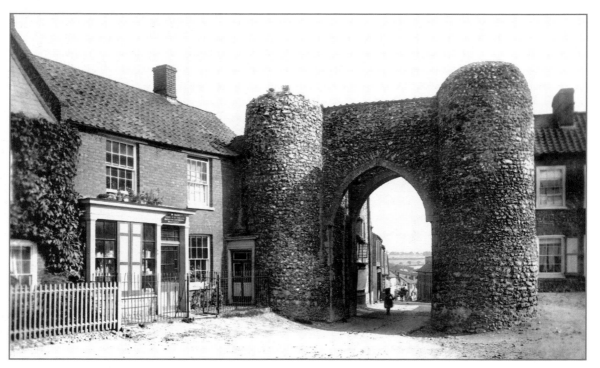

Castle Acre, The Old Gate 1891 29111
This narrow gateway, constructed of cobbled flint and brickwork, was built in the 13th century to defend the northern entrance of this well-preserved town, which was also fortified by earthworks connected to the west side of the castle. The shop premises and house on the left-hand side of the picture have been demolished. The cottages on the right-hand side are constructed from building materials taken from the castle ruins, as is the case with many other properties in the town.

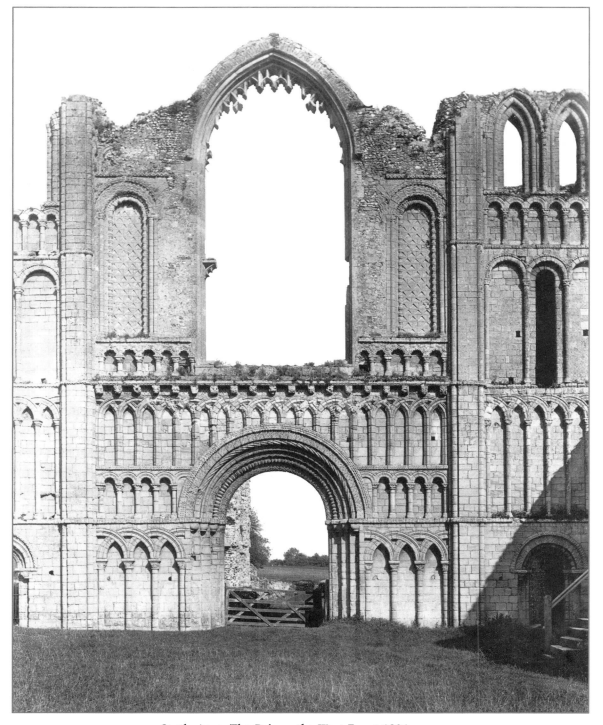

Castle Acre, The Priory, the West Front 1891 29113
This part of Castle Acre Priory is one of the best preserved ruins in Norfolk. It shows the beautiful Norman façade.
The local church contains an ancient font with fine tabernacle work, which came from the Priory.

▼ **Gayton, The Mill c1955** G287053
The owners of Gayton Flour Mill built all these properties to house their workers.
The mill had a bakery supplying bread for the whole village, which was displayed in
baskets and delivered by horse and cart. Depending on the strength of the wind,
the employees were called out day or night to work the mill.

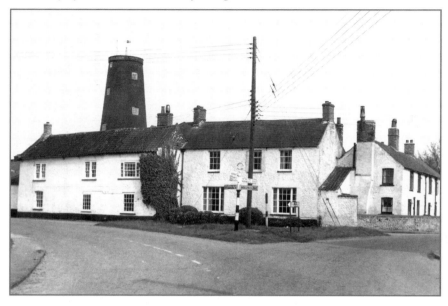

▼ **Gayton, The Inn c1955** G287049
Fresh vegetables have just been delivered to the Rampant Horse Pub. Police
officers welcomed the food and drink which they received here on their way to
Norwich jail with convicted prisoners. On the left of the leisurely-driven tractor is
Alan Howard's butcher's shop, which has been in the same family since 1927.

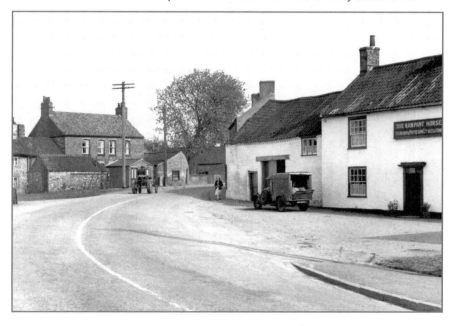

▲ **Gayton, The Post Office
1955** G287048
The first postmaster of
this very busy post office
was Mr Fred Wanford,
who transferred the
business in 1908 to his
relatives, the Borley
family. They are still in
residence.

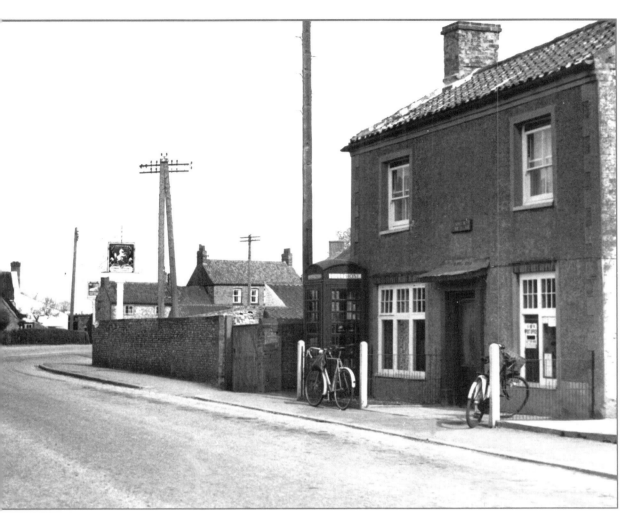

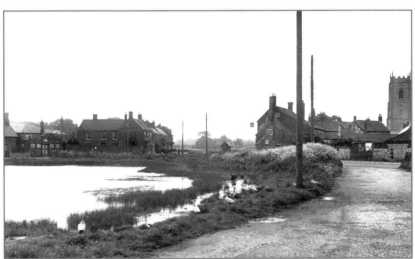

◀ **Great Massingham
The Village Pond c1965**
G210002
On the edge of the pond we can see Tony Simpson's black labrador having a paddle - he is well-trained, so the ducks are quite safe. In the centre is W Seapey's drapery and grocery store. On the left is the splendid Victorian façade of the Oddfellows Hall. The depth of the village well is said to equal the height of St Mary's church tower. Most of the buildings on the right belong to the Swan Pub; they contained the bullock yard, and this was a meeting place for local farmers and their workers.

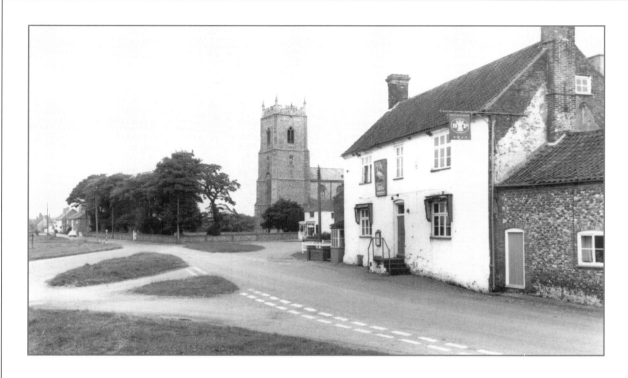

Great Massingham
The Swan and the Church c1965 G210015
The Swan is one of the last pubs to survive in this village.
During the last war there were five pubs; these, together with the
village stores, and sometimes the church, were havens for airmen
serving at the nearby RAF station, where Blenheim bombers were
based. The history of the Swan goes back to the days of the
stagecoach. The drivers used the village as a stopping point to rest
their horses, and most of the passengers stayed overnight in the pub.
In the cellars of the pub is a lock-up cell where errant locals spent the
night without the comfort which the customers upstairs enjoyed.

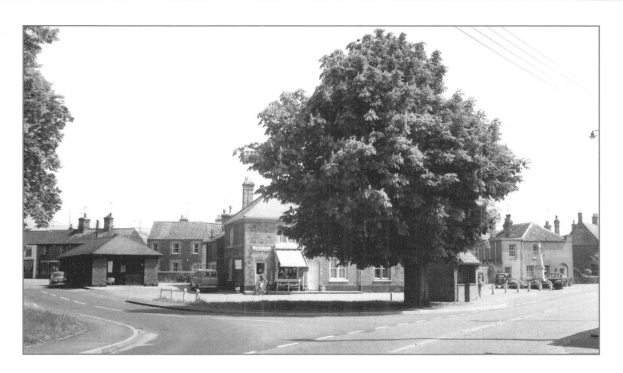

Snettisham
Market Place c1955 S464017
This horse chestnut tree became hollow and unsafe. The Council authorised that it should be filled with concrete, but this only prolonged its life for a brief period and it has since been chopped down, and a replacement planted. Behind the war memorial is Barclays Bank, which is now a bistro. Snettisham, like most villages, used to be self-contained, with shopkeepers selling all kinds of products to the locals. In the centre of the picture is Mr E Dewer's tobacconist shop. He was also the village milkman, and shared his premises with Mr Eldon the hairdresser. The white shop on the very left is a father and son business, run by Mr Percy Meek, a basket-maker and greengrocer. On the left side of the picture, under the tree, is an area called Ladies Walk; here an open market was held every Saturday. Behind the open garage is Hall Road, the main shopping street of the village.

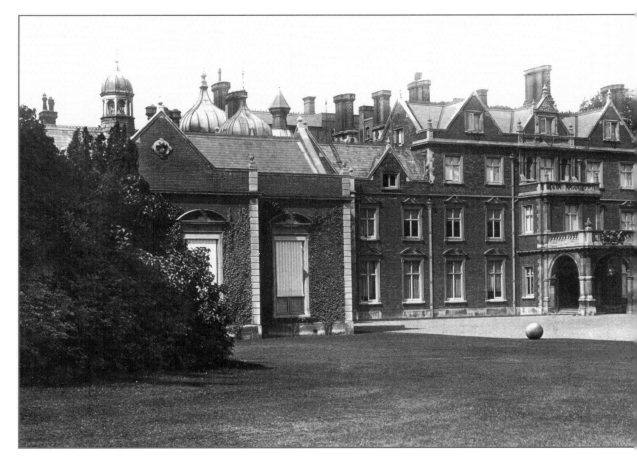

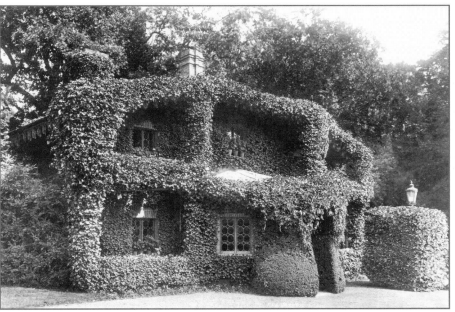

◀ **Sandringham
The Entrance Lodge
1896** 38401
This entrance lodge to
the house and gardens
was private until the
area was opened to the
public for the first time
in 1908. All moneys
from admission charges
go to a huge list of
charities, and garden
produce is given to
local hospitals.

◄ **Sandringham, Sandringham House 1896** 38395
This picture shows the east front of the house, which is a retreat for the Royal Family, providing private space within the building and the grounds, so that they can then indulge their private pastimes.

Sandringham ►
The War Memorial
1921 71066
This War Memorial is not far from Sandringham House; it was unveiled by King George V in May 1920 in memory of those from the estate who gave their lives in the First World War. In 1953 the Queen Mother unveiled further names of those killed in the Second World War.

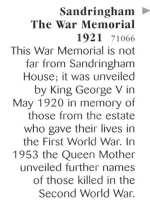

◄ **Sandringham**
The Gardener's Cottage
1927 79758
This is the Head Gardener's cottage in an area not open to the public, although the gardens are occasionally opened in aid of good causes or charity. The teak greenhouses are named after King Edward VII's famous racehorse Persimmon. They are used for the culture of orchids, tomatoes, roses and other plants, as well as for pot plants and cut flowers for the house. At the time of this photograph there were over eighty gardeners at work in the grounds.

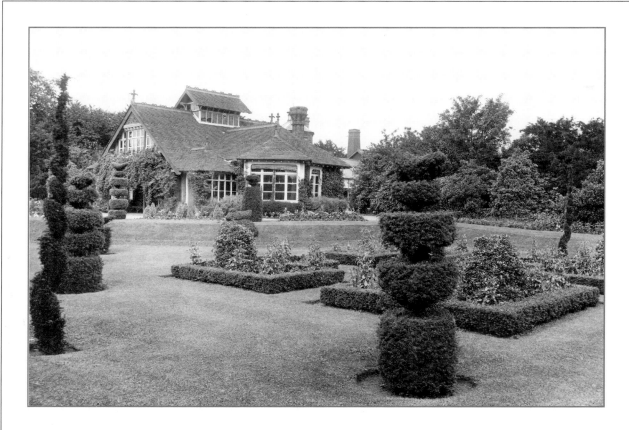

Sandringham
The Dutch Gardens and the Lost Dairy 1927 79763
Princess Alexandra had a dairy built near the stables. It was based
on a design similar to the Swiss cottage standing in the grounds
of Osborne House, Queen Victoria's retreat on the Isle of Wight.
The dairy really does look like a Swiss cottage, and here
Princess Alexandra entertained her guests to tea. The business end
of the premises is covered with tiles, which were a present from
the future King Edward VII; he selected and ordered them for the
purpose when he was in Bombay some years earlier. At one time
the Princess and her daughters were found engaged in making pats
of butter themselves. The milk came from a herd of cows imported
from her homeland in Denmark. The dairy was popular, and was
visited by notable guests including Queen Victoria, who presented
a tea service decorated with views of Balmoral.

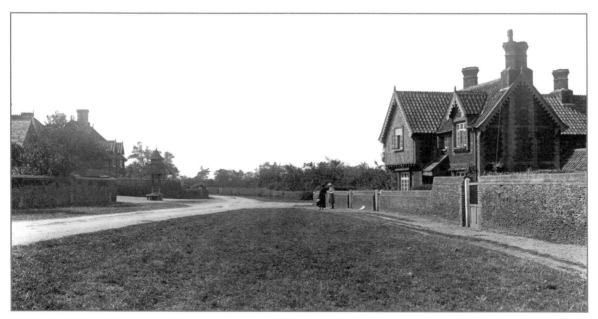

Wolferton, The Village 1921 71062
This tranquil village is one of the jewels of the Sandringham Estate. It not only encompasses the Royal Stud, but it is also often the focus of attention when any members of the royal family and their often important guests arrive at the railway station. Sandringham estate workers live here, as they do in the other six villages forming part of the Sandringham Estate.

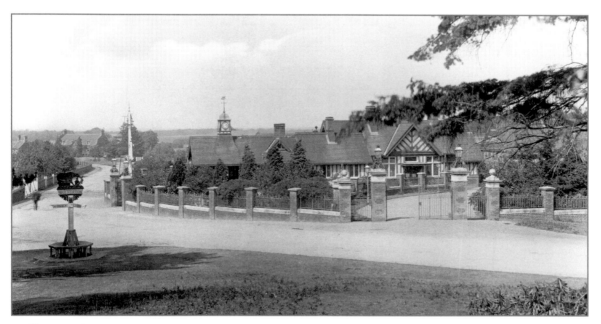

Wolferton, The Station 1921 71063
Known as the Royal Station, Wolferton was on the King's Lynn to Hunstanton line of the Great Eastern Railway. It has a beautiful setting, and our imaginations are aroused when we think of all the kings and queens who arrived on the Royal Train. It was used for forty-five years more from the time when this picture was taken, during which time over 640 royal trains arrived and departed. Note the crowns on top of the lamps of the gate posts.

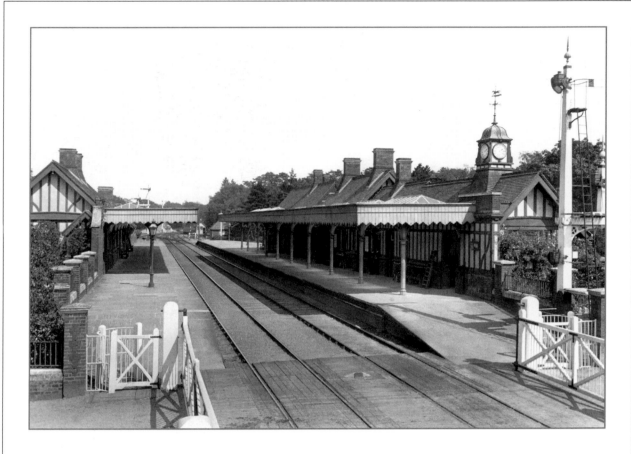

Wolferton
The Station 1921 71064

It is not surprising that this Royal Station is kept in tip-top
condition with not a speck of litter in sight on or off the track.
Its public rooms were enlarged, together with a set of private royal
rooms, which were designed and built in 1898 and situated on the
opposite platform. The building contains a central hallway leading
from the platform to the station car park. Queen Alexandra even
had her own retiring room, and so did King Edward VII. All the
rooms are oak-panelled, and many generations of the
royal family have quietly rested here after their journey
from London before making the final stage of their trip to
Sandringham House by road. On occasions they used the rooms
as a shooting lodge.

Wolferton
The Village Sign c1955 W354019

This sign was erected in early 1912, and had a seat at its base. It depicts the great wolf Fenrir of Viking mythology, one of the offspring of Loki, the god of destruction, being fed by Tyr, the god of martial honour. The monster was restrained by a magic silken cord whose existence the wolf suspected, so Tyr placed his right arm in its jaws to prove no guile. Fenrir could not escape from the magic rope chaining him to the rock. The colourful scene shows Tyr in his golden armour on meadows covered with primroses. On stormy nights, even above the sound of the north winds it is said you can still hear the howling of Fenrir in the village pine woods.

Wolferton
The Village c1955 W354010

On the left is Wolferton's Social Club, which was built in 1893. The sheltered seat was used by the children as a meeting place and to play around. Many can recall when they were spoken to by royalty, who often walked, rode or were driven through the village.

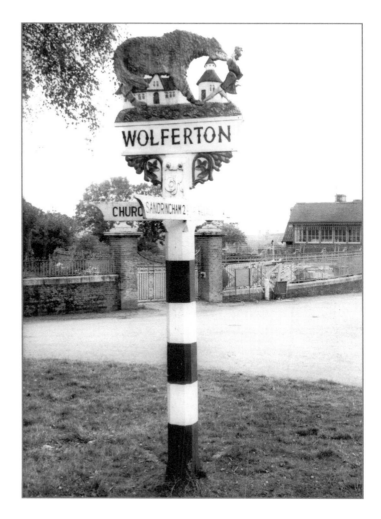

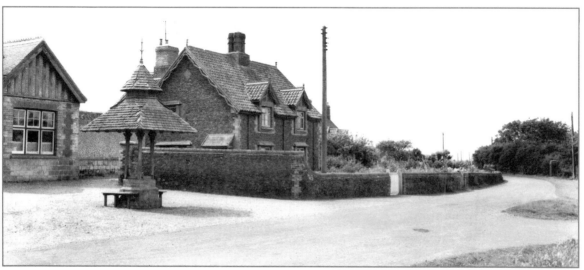

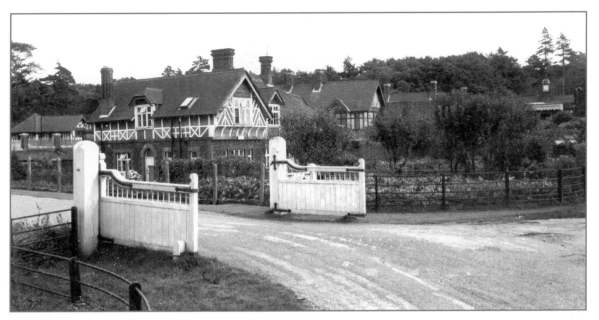

Wolferton, The Post Office c1955 W354022
The building in the foreground is the village shop and post office - we can just see a pillar-box outside the front door. The only shopkeeper in the village was Mrs May Southgate, she was born in Wolferton and lived there all her life, and delivered produce to most of its residents. These often included royalty spending time in a country retreat at Wood Farm close to the Queen's Stud.

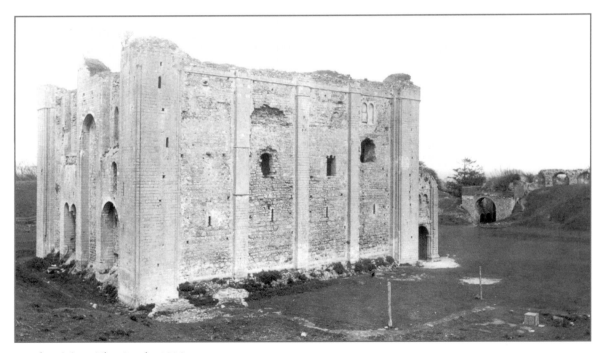

Castle Rising, The Castle 1898 40894
This is one of the largest keeps in the country, richly decorated inside with a well-preserved medieval kitchen. The castle is built on a massive defensive earthwork, giving unrivalled views across the land and out to sea.

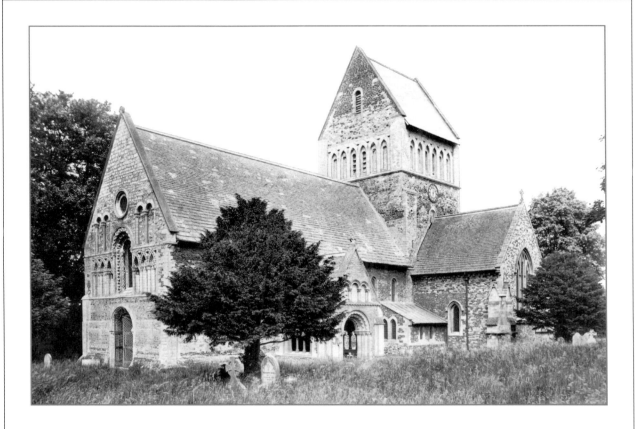

Castle Rising
The Church 1908 60030

Dating from the early part of the 12th century, this beautiful church is made of Sandringham sandstone and carrstone, which are both found locally; the only imported stone came by water along the river Nene and across the Wash to the local harbour, which was operating until the late 17th century. There were enormous changes made to the roof and tower and other parts of the church in the 19th century. It is unusual that there are no windows on the north side; this was intentional, to protect the congregation from the ravages of the weather, for the north side faces the sea. The interior of this well-kept church must be one of the best in East Anglia. There are so many interesting things to see, not least the font, which has three cats' faces on its side (the church is dedicated to St Felix - felis is Latin for cat). The font can hold twenty-five gallons of water to cater for the total immersion of infants during their baptism, which was the custom until the 16th century.

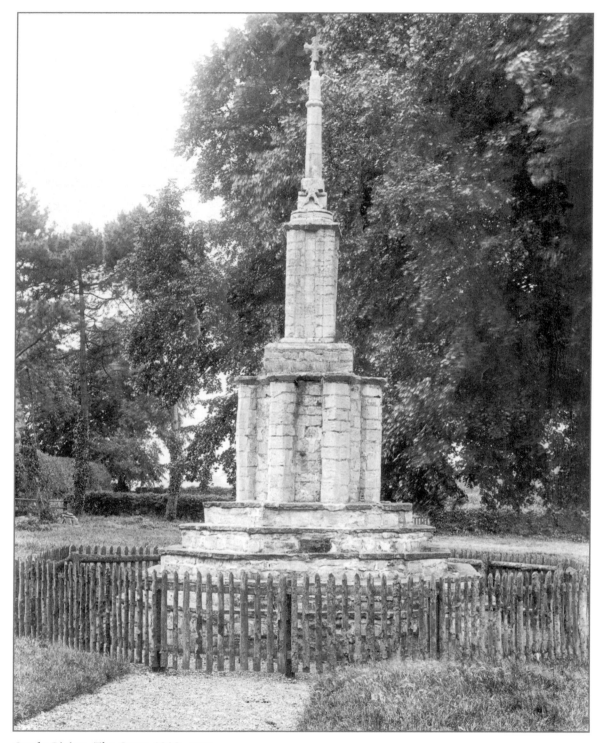

Castle Rising, The Cross 1908 60033
This is a traditional village cross, and here on market days all kinds of products were sold. It is made of Barnock stone, and is set on a plinth of stone taken from the castle.

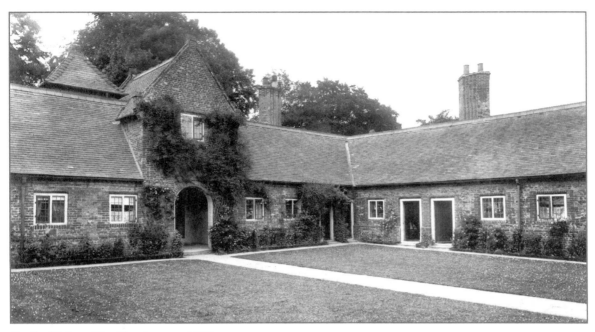

Castle Rising, The Almshouses 1908 60034
The eccentric Earl of Northampton, Henry Howard, founded this almshouse in the reign of James I. The house was originally called Bede House, and it has not been altered significantly since the days of the Stuarts. Neither has the costume of its inhabitants, which is high-peaked hats and scarlet cloaks with a Howard badge affixed to them. These are worn on special days such as saints' days, royal occasions and special holidays.

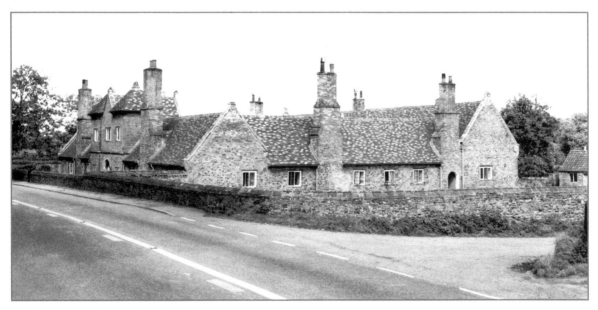

Castle Rising, Trinity Hospital c1960 C45016
This is an exterior view of Bede House. It was never used as a hospital in the strictest sense, although the building bears a resemblance to the Fisherman's Hospital in Yarmouth. The occupants are ladies on their own who are eligible to live here only when certain conditions are met and kept. The property is meticulously maintained, and it has a homely atmosphere.

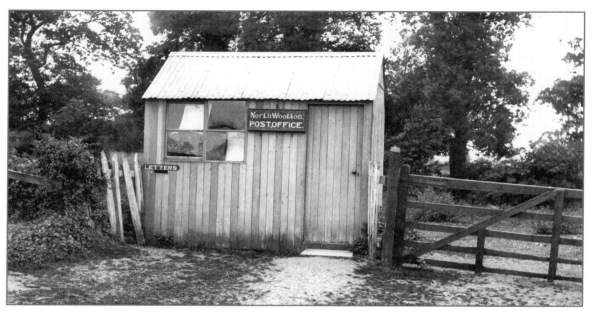

North Wootton, The Post Office 1908 60035
Only the locals knew where to find this well-hidden post office. Letters were collected every day at 6.35pm, apart from Sundays. Sub-postmistress Mrs F A Page sold basic Royal Mail items and was always keen to hear and talk about current and local affairs, especially family and village activities, which of course she never passed on!

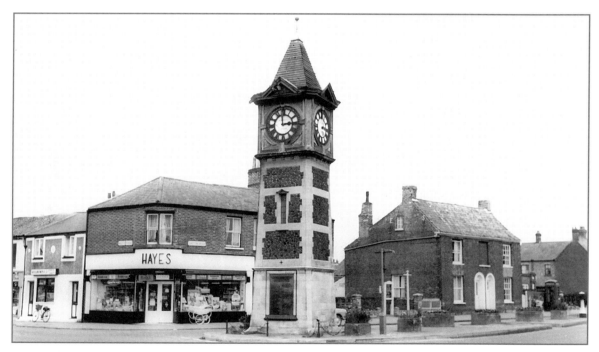

Gaywood, The Clock Tower c1965 G189020
The clock tower is an uncommon form of memorial to the fallen of World War I. It was first erected in 1920, and has been moved slightly to avoid obstructing the traffic and to prevent damage. Once a village in its own right, Gaywood has become no more than a suburb of King's Lynn.

Index

Frith Book Co Titles

www.francisfrith.co.uk

The Frith Book Company publishes over 100 new titles each year. A selection of those currently available are listed below. For latest catalogue please contact Frith Book Co.

Town Books 96 pages, approx 100 photos. County and Themed Books 128 pages, approx 150 photos (unless specified). All titles hardback laminated case and jacket except those indicated pb (paperback)

Title	ISBN	Price	Title	ISBN	Price
Amersham, Chesham & Rickmansworth (pb)	1-85937-340-2	£9.99	Derby (pb)	1-85937-367-4	£9.99
Ancient Monuments & Stone Circles	1-85937-143-4	£17.99	Derbyshire (pb)	1-85937-196-5	£9.99
Aylesbury (pb)	1-85937-227-9	£9.99	Devon (pb)	1-85937-297-x	£9.99
Bakewell	1-85937-113-2	£12.99	Dorset (pb)	1-85937-269-4	£9.99
Barnstaple (pb)	1-85937-300-3	£9.99	Dorset Churches	1-85937-172-8	£17.99
Bath (pb)	1-85937419-0	£9.99	Dorset Coast (pb)	1-85937-299-6	£9.99
Bedford (pb)	1-85937-205-8	£9.99	Dorset Living Memories	1-85937-210-4	£14.99
Berkshire (pb)	1-85937-191-4	£9.99	Down the Severn	1-85937-118-3	£14.99
Berkshire Churches	1-85937-170-1	£17.99	Down the Thames (pb)	1-85937-278-3	£9.99
Blackpool (pb)	1-85937-382-8	£9.99	Down the Trent	1-85937-311-9	£14.99
Bognor Regis (pb)	1-85937-431-x	£9.99	Dublin (pb)	1-85937-231-7	£9.99
Bournemouth	1-85937-067-5	£12.99	East Anglia (pb)	1-85937-265-1	£9.99
Bradford (pb)	1-85937-204-x	£9.99	East London	1-85937-080-2	£14.99
Brighton & Hove(pb)	1-85937-192-2	£8.99	East Sussex	1-85937-130-2	£14.99
Bristol (pb)	1-85937-264-3	£9.99	Eastbourne	1-85937-061-6	£12.99
British Life A Century Ago (pb)	1-85937-213-9	£9.99	Edinburgh (pb)	1-85937-193-0	£8.99
Buckinghamshire (pb)	1-85937-200-7	£9.99	England in the 1880s	1-85937-331-3	£17.99
Camberley (pb)	1-85937-222-8	£9.99	English Castles (pb)	1-85937-434-4	£9.99
Cambridge (pb)	1-85937-422-0	£9.99	English Country Houses	1-85937-161-2	£17.99
Cambridgeshire (pb)	1-85937-420-4	£9.99	Essex (pb)	1-85937-270-8	£9.99
Canals & Waterways (pb)	1-85937-291-0	£9.99	Exeter	1-85937-126-4	£12.99
Canterbury Cathedral (pb)	1-85937-179-5	£9.99	Exmoor	1-85937-132-9	£14.99
Cardiff (pb)	1-85937-093-4	£9.99	Falmouth	1-85937-066-7	£12.99
Carmarthenshire	1-85937-216-3	£14.99	Folkestone (pb)	1-85937-124-8	£9.99
Chelmsford (pb)	1-85937-310-0	£9.99	Glasgow (pb)	1-85937-190-6	£9.99
Cheltenham (pb)	1-85937-095-0	£9.99	Gloucestershire	1-85937-102-7	£14.99
Cheshire (pb)	1-85937-271-6	£9.99	Great Yarmouth (pb)	1-85937-426-3	£9.99
Chester	1-85937-090-x	£12.99	Greater Manchester (pb)	1-85937-266-x	£9.99
Chesterfield	1-85937-378-x	£9.99	Guildford (pb)	1-85937-410-7	£9.99
Chichester (pb)	1-85937-228-7	£9.99	Hampshire (pb)	1-85937-279-1	£9.99
Colchester (pb)	1-85937-188-4	£8.99	Hampshire Churches (pb)	1-85937-207-4	£9.99
Cornish Coast	1-85937-163-9	£14.99	Harrogate	1-85937-423-9	£9.99
Cornwall (pb)	1-85937-229-5	£9.99	Hastings & Bexhill (pb)	1-85937-131-0	£9.99
Cornwall Living Memories	1-85937-248-1	£14.99	Heart of Lancashire (pb)	1-85937-197-3	£9.99
Cotswolds (pb)	1-85937-230-9	£9.99	Helston (pb)	1-85937-214-7	£9.99
Cotswolds Living Memories	1-85937-255-4	£14.99	Hereford (pb)	1-85937-175-2	£9.99
County Durham	1-85937-123-x	£14.99	Herefordshire	1-85937-174-4	£14.99
Croydon Living Memories	1-85937-162-0	£9.99	Hertfordshire (pb)	1-85937-247-3	£9.99
Cumbria	1-85937-101-9	£14.99	Horsham (pb)	1-85937-432-8	£9.99
Dartmoor	1-85937-145-0	£14.99	Humberside	1-85937-215-5	£14.99
			Hythe, Romney Marsh & Ashford	1-85937-256-2	£9.99

Available from your local bookshop or from the publisher

Frith Book Co Titles (continued)

Title	ISBN	Price	Title	ISBN	Price
Ipswich (pb)	1-85937-424-7	£9.99	St Ives (pb)	1-85937415-8	£9.99
Ireland (pb)	1-85937-181-7	£9.99	Scotland (pb)	1-85937-182-5	£9.99
Isle of Man (pb)	1-85937-268-6	£9.99	Scottish Castles (pb)	1-85937-323-2	£9.99
Isles of Scilly	1-85937-136-1	£14.99	Sevenoaks & Tunbridge	1-85937-057-8	£12.99
Isle of Wight (pb)	1-85937-429-8	£9.99	Sheffield, South Yorks (pb)	1-85937-267-8	£9.99
Isle of Wight Living Memories	1-85937-304-6	£14.99	Shrewsbury (pb)	1-85937-325-9	£9.99
Kent (pb)	1-85937-189-2	£9.99	Shropshire (pb)	1-85937-326-7	£9.99
Kent Living Memories	1-85937-125-6	£14.99	Somerset	1-85937-153-1	£14.99
Lake District (pb)	1-85937-275-9	£9.99	South Devon Coast	1-85937-107-8	£14.99
Lancaster, Morecambe & Heysham (pb)	1-85937-233-3	£9.99	South Devon Living Memories	1-85937-168-x	£14.99
Leeds (pb)	1-85937-202-3	£9.99	South Hams	1-85937-220-1	£14.99
Leicester	1-85937-073-x	£12.99	Southampton (pb)	1-85937-427-1	£9.99
Leicestershire (pb)	1-85937-185-x	£9.99	Southport (pb)	1-85937-425-5	£9.99
Lincolnshire (pb)	1-85937-433-6	£9.99	Staffordshire	1-85937-047-0	£12.99
Liverpool & Merseyside (pb)	1-85937-234-1	£9.99	Stratford upon Avon	1-85937-098-5	£12.99
London (pb)	1-85937-183-3	£9.99	Suffolk (pb)	1-85937-221-x	£9.99
Ludlow (pb)	1-85937-176-0	£9.99	Suffolk Coast	1-85937-259-7	£14.99
Luton (pb)	1-85937-235-x	£9.99	Surrey (pb)	1-85937-240-6	£9.99
Maidstone	1-85937-056-x	£14.99	Sussex (pb)	1-85937-184-1	£9.99
Manchester (pb)	1-85937-198-1	£9.99	Swansea (pb)	1-85937-167-1	£9.99
Middlesex	1-85937-158-2	£14.99	Tees Valley & Cleveland	1-85937-211-2	£14.99
New Forest	1-85937-128-0	£14.99	Thanet (pb)	1-85937-116-7	£9.99
Newark (pb)	1-85937-366-6	£9.99	Tiverton (pb)	1-85937-178-7	£9.99
Newport, Wales (pb)	1-85937-258-9	£9.99	Torbay	1-85937-063-2	£12.99
Newquay (pb)	1-85937-421-2	£9.99	Truro	1-85937-147-7	£12.99
Norfolk (pb)	1-85937-195-7	£9.99	Victorian and Edwardian Cornwall	1-85937-252-x	£14.99
Norfolk Living Memories	1-85937-217-1	£14.99	Victorian & Edwardian Devon	1-85937-253-8	£14.99
Northamptonshire	1-85937-150-7	£14.99	Victorian & Edwardian Kent	1-85937-149-3	£14.99
Northumberland Tyne & Wear (pb)	1-85937-281-3	£9.99	Vic & Ed Maritime Album	1-85937-144-2	£17.99
North Devon Coast	1-85937-146-9	£14.99	Victorian and Edwardian Sussex	1-85937-157-4	£14.99
North Devon Living Memories	1-85937-261-9	£14.99	Victorian & Edwardian Yorkshire	1-85937-154-x	£14.99
North London	1-85937-206-6	£14.99	Victorian Seaside	1-85937-159-0	£17.99
North Wales (pb)	1-85937-298-8	£9.99	Villages of Devon (pb)	1-85937-293-7	£9.99
North Yorkshire (pb)	1-85937-236-8	£9.99	Villages of Kent (pb)	1-85937-294-5	£9.99
Norwich (pb)	1-85937-194-9	£8.99	Villages of Sussex (pb)	1-85937-295-3	£9.99
Nottingham (pb)	1-85937-324-0	£9.99	Warwickshire (pb)	1-85937-203-1	£9.99
Nottinghamshire (pb)	1-85937-187-6	£9.99	Welsh Castles (pb)	1-85937-322-4	£9.99
Oxford (pb)	1-85937-411-5	£9.99	West Midlands (pb)	1-85937-289-9	£9.99
Oxfordshire (pb)	1-85937-430-1	£9.99	West Sussex	1-85937-148-5	£14.99
Peak District (pb)	1-85937-280-5	£9.99	West Yorkshire (pb)	1-85937-201-5	£9.99
Penzance	1-85937-069-1	£12.99	Weymouth (pb)	1-85937-209-0	£9.99
Peterborough (pb)	1-85937-219-8	£9.99	Wiltshire (pb)	1-85937-277-5	£9.99
Piers	1-85937-237-6	£17.99	Wiltshire Churches (pb)	1-85937-171-x	£9.99
Plymouth	1-85937-119-1	£12.99	Wiltshire Living Memories	1-85937-245-7	£14.99
Poole & Sandbanks (pb)	1-85937-251-1	£9.99	Winchester (pb)	1-85937-428-x	£9.99
Preston (pb)	1-85937-212-0	£9.99	Windmills & Watermills	1-85937-242-2	£17.99
Reading (pb)	1-85937-238-4	£9.99	Worcester (pb)	1-85937-165-5	£9.99
Romford (pb)	1-85937-319-4	£9.99	Worcestershire	1-85937-152-3	£14.99
Salisbury (pb)	1-85937-239-2	£9.99	York (pb)	1-85937-199-x	£9.99
Scarborough (pb)	1-85937-379-8	£9.99	Yorkshire (pb)	1-85937-186-8	£9.99
St Albans (pb)	1-85937-341-0	£9.99	Yorkshire Living Memories	1-85937-166-3	£14.99

See Frith books on the internet www.francisfrith.co.uk

FRITH PRODUCTS & SERVICES

Francis Frith would doubtless be pleased to know that the pioneering publishing venture he started in 1860 still continues today. A hundred and forty years later, The Francis Frith Collection continues in the same innovative tradition and is now one of the foremost publishers of vintage photographs in the world. Some of the current activities include:

Interior Decoration

Today Frith's photographs can be seen framed and as giant wall murals in thousands of pubs, restaurants, hotels, banks, retail stores and other public buildings throughout the country. In every case they enhance the unique local atmosphere of the places they depict and provide reminders of gentler days in an increasingly busy and frenetic world.

Product Promotions

Frith products are used by many major companies to promote the sales of their own products or to reinforce their own history and heritage. Frith promotions have been used by Hovis bread, Courage beers, Scots Porage Oats, Colman's mustard, Cadbury's foods, Mellow Birds coffee, Dunhill pipe tobacco, Guinness, and Bulmer's Cider.

Genealogy and Family History

As the interest in family history and roots grows world-wide, more and more people are turning to Frith's photographs of Great Britain for images of the towns, villages and streets where their ancestors lived; and, of course, photographs of the churches and chapels where their ancestors were christened, married and buried are an essential part of every genealogy tree and family album.

Frith Products

All Frith photographs are available Framed or just as Mounted Prints and Posters (size 23 x 16 inches). These may be ordered from the address below. From time to time other products - Address Books, Calendars, Table Mats, etc - are available.

The Internet

Already twenty thousand Frith photographs can be viewed and purchased on the internet through the Frith websites and a myriad of partner sites.

For more detailed information on Frith companies and products, look at these sites:

www.francisfrith.co.uk
www.francisfrith.com
(for North American visitors)

See the complete list of Frith Books at:

www.francisfrith.co.uk

This web site is regularly updated with the latest list of publications from the Frith Book Company. If you wish to buy books relating to another part of the country that your local bookshop does not stock, you may purchase on-line.

For further information, trade, or author enquiries please contact us at the address below:
The Francis Frith Collection, Frith's Barn, Teffont, Salisbury, Wiltshire, England SP3 5QP.
Tel: +44 (0)1722 716 376 Fax: +44 (0)1722 716 881 Email: sales@francisfrith.co.uk

See Frith books on the internet www.francisfrith.co.uk